Janet Whittle's
Watercolour
Flowers

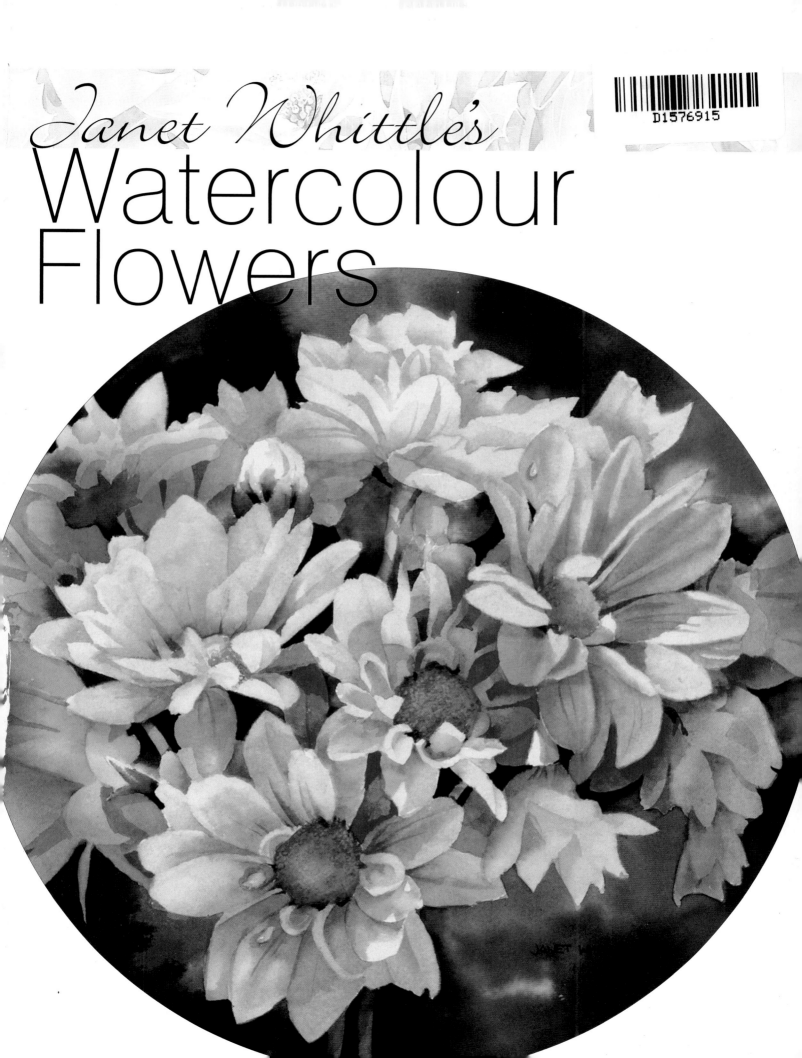

D1576915

Dedication

To my sister Sue, for being the lovely
person you are, this is for you.

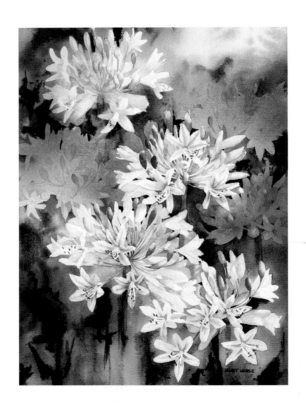

Janet Whittle's
Watercolour
Flowers

An inspirational step-by-step guide to colour and techniques

WARRINGTON BOROUGH COUNCIL	
Askews	21-Jun-2007

First published in Great Britain 2007

Search Press Limited
Wellwood, North Farm Road,
Tunbridge Wells, Kent TN2 3DR

Text copyright © Janet Whittle 2007

Photographs by Roddy Paine Photographic Studio, and David and Shelley Marsden

Photographs copyright © Search Press Ltd. 2007

Design copyright © Search Press Ltd. 2007

All rights reserved. No part of this book, text, photographs or illustrations may be reproduced or transmitted in any form or by any means by print, photoprint, microfilm, microfiche, photocopier, internet or in anyway known or as yet unknown, or stored in a retrieval system, without written permission obtained beforehand from Search Press.

ISBN-10: 1-84448-132-8
ISBN-13: 978-1-84448-132-3

The Publishers and author can accept no responsibility for any consequences arising from the information, advice or instructions given in this publication.

Suppliers
If you have difficulty in obtaining any of the materials and equipment mentioned in this book, please visit the Search Press website for details of suppliers: www.searchpress.com

Publishers' note

All the step-by-step photographs in this book feature the author, Janet Whittle, demonstrating painting and drawing flowers in watercolour. No models have been used.

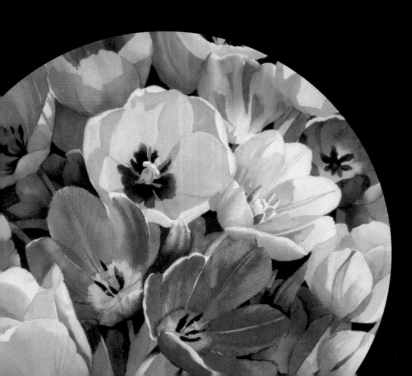

Acknowledgements

I would like to thank friends Sue and Di, who without hesitation have always given me help and support whenever I have floundered. Thanks also to David and Shelley for their friendship, for always making the time to photograph my work, and for dragging me into this century so that this book has been easier to assemble.

I also wish to thank Katie Chester for knitting things together and sitting through all the step-by-steps with the patience of a saint, and Roddy Paine for his expert photography. Many thanks to Roz Dace for commissioning this book, and Juan Hayward for making sense of all my paraphernalia, both of whom do more than I know. Thanks also to the students who appreciate the hard work that goes into painting and never fail to say so; without you this book would be not only impossible but pointless. I thank you all.

To my husband Barry and sons Matt and Duncan, all my thanks, especially my son Matt for sorting out the computer time after time without a murmur and for tackling any scheme I happen to come up with without even flinching.

And finally to friends, with love, without whom tomorrow would be just another day.

Cover
Maigold
51 x 30cm (20 x 12in)

Page 1
Daisy Circle
23cm (9in) diameter

Page 2
Agapanthus
35 x 48cm (14 x 19in)

Page 3
Peony
46 x 63cm (18 x 25in)

Page 5
Gift of Tulips
33 x 33cm (13 x 13in)

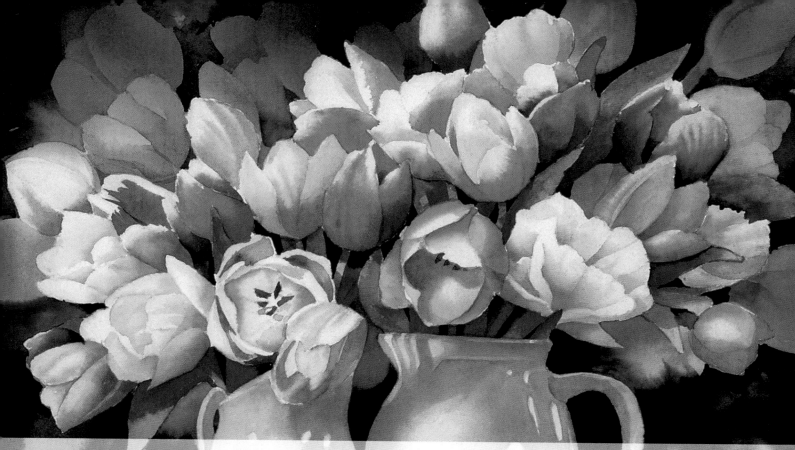

Contents

Introduction 6

Materials and equipment 8

Colour 14

Composition 26

Drawing 34

Getting started 42

Techniques 44

Shadows and sunshine 56

Projects

Tulips 60

Roses 70

Fuchsias 84

Anemones 94

Daffodils 106

Irises 116

Index 128

Introduction

I am really excited about this book, and have thoroughly enjoyed writing it. For me, my life as a painter is like a journey. In the three years since my first book, *Painting Flowers and Plants*, was published, much has happened to make demonstrating the techniques easier, so the step-by-step projects should be even clearer and easier to follow than before. I have also discovered some exciting new colours and mixes which I have added to my palette, and which I hope you enjoy working with as much as I do, and so the journey goes on ...

I hope you enjoy working your way through the projects, and that they will inspire you to go on and produce your own paintings using some of the techniques you have learned. Included in this book are several pencil sketches, including a step-by-step project culminating in a finished pencil drawing and a painting. Producing a pencil drawing of your subject boosts your confidence and enables you to better understand the flower and its form before undertaking a painting.

You are encouraged throughout the book to try different approaches to painting, such as painting in a circular frame, combining different flowers for effect, vignetting, still-life compositions and lots more. The magic is in letting go and using your imagination; not holding on too tightly to your reference photographs; and enjoying the sensation of allowing colours to flow over the paper.

Janet

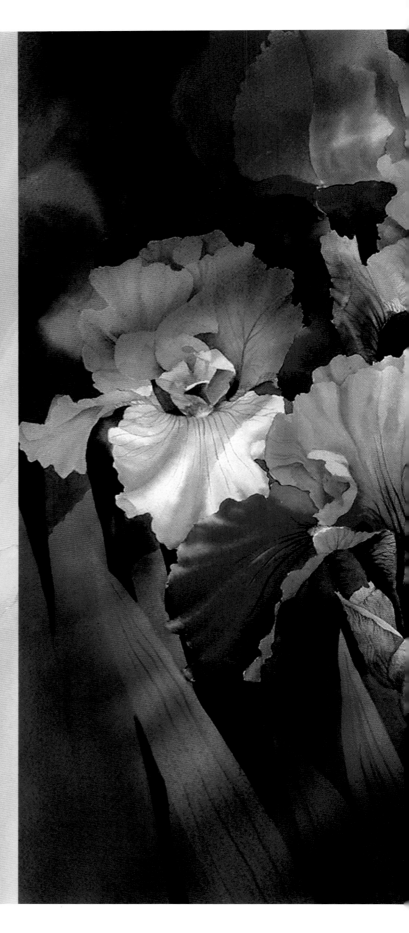

Jelly Roll and Honky Tonk Blues
51 x 38cm (20 x 15in)

Using cool blues and turquoise mixes, I have attempted to recreate the peaceful mood of early morning. The colours chosen have a dramatic effect on the appearance of the flowers, even though they remain essentially true to life. The background flowers were glazed with purples and blues at the end of the painting to push them back, directing focus on to the foreground flower, as a way of creating interest and depth.

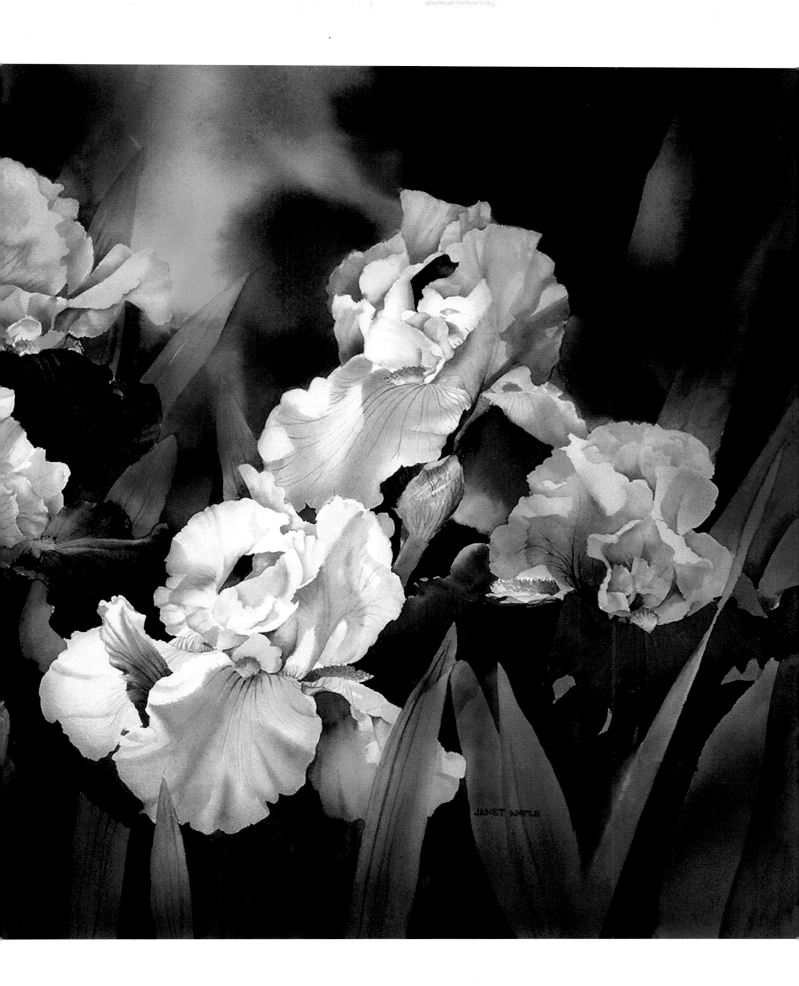

JANET WHETLE

Materials and equipment

I am forever changing the materials and equipment that I use, and you should do the same. It is part of what makes painting exciting for me. Never be afraid to try out a new way of doing something, and don't be put off just because someone else does it differently or tells you it is not the way it's done! By all means take advice when you are first starting out as a painter, but as you progress, have the confidence to make your own decisions and experiment.

'Limited palette' is not in my vocabulary. I love colour, and am constantly trying out new colours and mixes. Consequently some of the colours I have used in the paintings in this book are not in my previous one. I often try out different brushes as well, but only my favourites are featured here.

If you are new to watercolour painting, you should start with just a few basic items of equipment – essentially paper, paint and brushes – and build up from there. Buying cheap items can be a false economy; generally, the better the materials you buy, the longer they will last and the more successful will be your painting.

Pure graphite pencils. These should be sharpened with a pencil sharpener.

Paper

I cannot repeat enough times that the paper you use is very important. All papers have different properties, and some of them can take quite a while to get used to. The paper you decide to use will depend on your style and technique, and you may decide to use a range of different papers. It is a big mistake to start a painting not knowing what paper it is you are using. A lot of students are so impatient they grab the first piece that comes to hand, completely unaware of what type it is or where it came from. Don't do it! Painting can be difficult enough without placing unnecessary obstacles in your path. Use the correct materials, and the better your chance of success.

The paper I most enjoy working with, and which I have used in the step-by-step projects in this book, is 300gsm (140lb) or 640gsm (300lb) NOT paper. This paper takes masking fluid readily and has a smooth finish. I always stretch the lighter-weight paper before beginning a painting (see page 43), as any cockling will create 'rivers' of paint, which is unacceptable.

Watercolour paper, 300gsm (140lb) and 640gsm (300lb) NOT.

Pencils

I use HB pencils for my initial line drawings as they are easy to erase. Should I need to do more drawing after the first washes I use a slightly softer, 2B pencil which is darker and will show up on the paint (this must be dry). It will also not dent the paper like a harder pencil.

For drawings, I use a range of pencils starting with F to glaze over a warm tone, and ending with the 9B pure graphite pencil for the really dark tones.

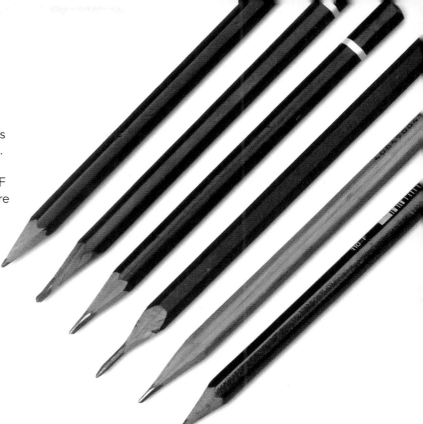

Other drawing equipment

I use a make-up brush for removing rubbed-off fragments of eraser and masking fluid so that I do not have to touch the paper, as the natural oils from your hands can smudge the paint or pencil lines, or make washes difficult if absorbed into the paper.

To remove pencil marks I use a plastic eraser or, for smaller areas, an electric eraser, which is demonstrated on page 37. A pencil sharpener is used to sharpen pure graphite pencils, and for other pencils I use a knife or scalpel as these give a better point. I use a pair of compasses to draw out the circular frames, should you wish to paint in this format.

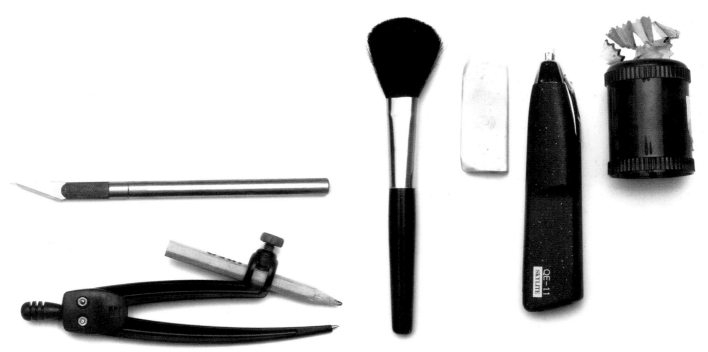

Equipment for transferring the design

I use a red biro for tracing over my designs when transferring them to watercolour paper as it shows up clearly against the black pencil outline (see page 43). Alternatively, I first trace off the design on to tracing paper using a black cartridge pen, and then transfer it on to watercolour paper. The advantage of this method is that I can keep the tracing and reuse it several times.

Paintbrushes

The basic brushes I use are a large wash brush, used mainly for wetting the paper; and Nos. 6, 7 and 8 round brushes, a 13mm (½in) flat brush, and a No. 000 and a small No. 3 rigger for veining. For removing paint and softening edges, I use a 13mm (½in) or 6mm (¼in) flat acrylic brush, as these are a little stiffer and therefore slightly more abrasive than watercolour brushes.

Paints

When I start a painting I use a large amount of paint in the background washes, then continue using the same colours throughout the remainder of the painting. I therefore prefer to use tubes of paint rather than pans because of the quantity of paint I use. If you wish to use both, top up pans with paint from tubes to begin with to avoid wastage.

Although students' colours are cheaper, artists' colours have far more vibrancy, remain moist for longer and are easier to use.

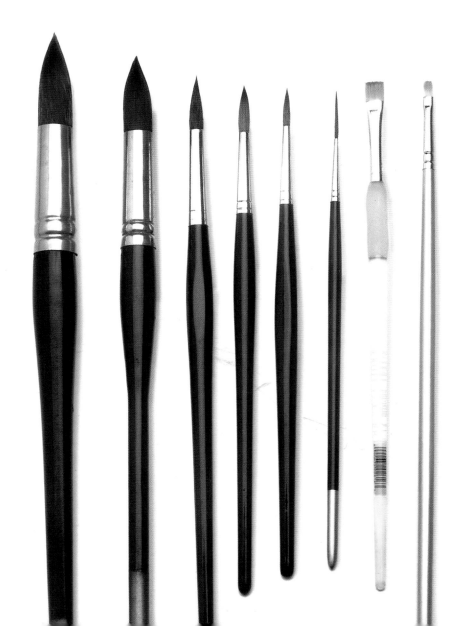

Palettes

I often use individual palettes for mixing my colours, but I mix the background washes in a large palette with five separate wells. The palette I use has a slanting base that allows you to make two mixes of the same colour in a single well: a fairly dense mix at the shallow end and, by dragging colour down to the deeper well, a fairly large quantity of a more watery mix at the other.

White porcelain palettes allow you to see the true colours of the paint, unchanged by any colour underneath. Some artists use an old china dinnerplate, or even a white plastic baking tray.

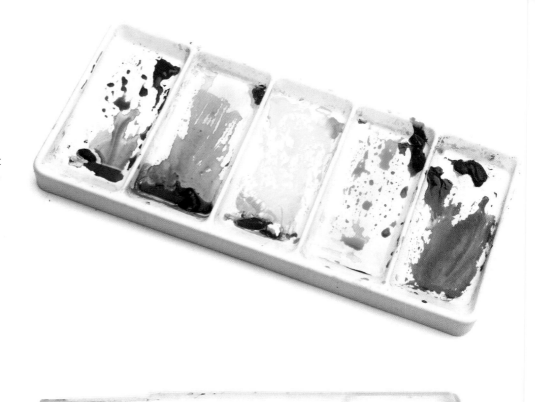

I use a pipette for adding water to a mix so that I do not have to rinse my brush every time.

Watercolour pencils I use mainly wet-in-wet, dampening the paper first then using the pencils while it is still wet. Examples of this technique are given on page 41.

Other painting equipment

A **water spray** is ideal for re-wetting your painting if it has dried unevenly, or diluting a wash while it is still wet. A **hairdryer** can be used to finish off the drying process, but it can dull the colours a little. If you do use one, make sure the shine has gone off your painting first. A **pair of scissors** is needed for cutting and trimming paper, and a **steel rule** for measuring and drawing out a frame for your picture, and as a guide for your scalpel when removing your finished painting from the drawing board if it has been stuck down with brown paper tape. I use two **water containers** – one to redampen my brush while I am painting and the other to hold clean water. A collapsible one is useful when travelling or painting outdoors. I use **masking tape** for preserving a border. A **plastic eraser** is needed for removing pencil lines as you work, and a **ceramic brush rest** keeps your loaded brushes raised while not in use. **Masking fluid**, applied with an **old paintbrush**, prevents paint from spreading to areas where it is not wanted. **Absorbent paper towel** is needed to adjust the amount of liquid in your brush and to mop up inevitable spills, and a **make-up brush** is useful for brushing away fragments of masking fluid and plastic eraser. A light spray of **fixative** applied to a finished drawing will stop it smudging, and for added protection I also attach a sheet of **tracing paper**, hinged along the top using masking tape. Finally, a **paper stretcher** is an excellent and fail-safe method of stretching paper. Paper stretchers are available in three different sizes and can be adjusted to fit any size of paper. By dampening only one side of the paper, you can start painting straight away if you want to.

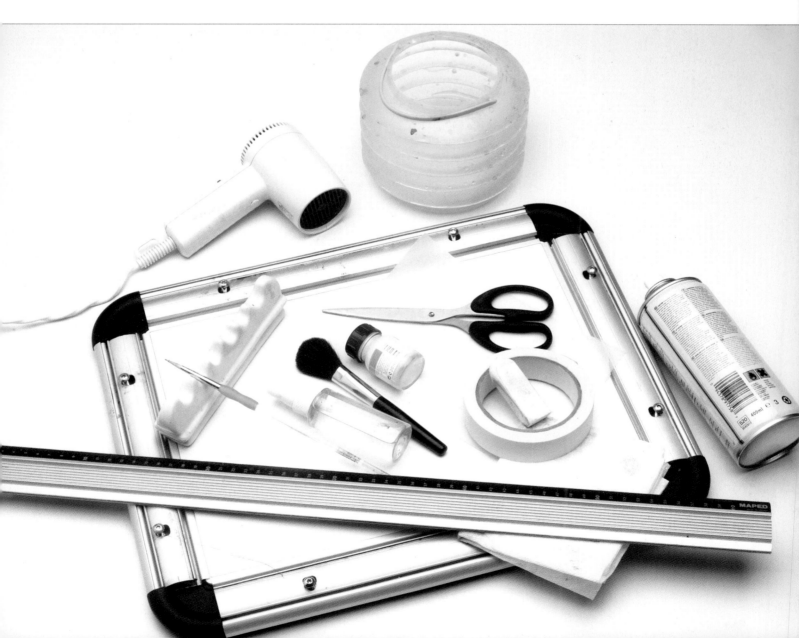

Colour

I feel that one of the main reasons people are initially attracted to a painting is the combination of colours used. If you are illustrating a flower and are going for a realistic approach, then the colours you use should match those of the real flower, but in the background you can use any colours you like, chosen to complement the colours of the flower.

You may wish to paint a combination of different flowers, as demonstrated later in this book. This could be a group of different types of flowers, as on pages 30–31, or a collection of flowers of the same species, as on page 17. Flowers of the same species often come in a variety of colours (see pages 20–21), so if you do not like the colour of the flower in your reference photograph, you can change it.

Colours bounce off one another and change depending on the amount of light reflecting off them, so many of the colours you see are not actually there, but are a result of the interplay of light and shade. This can be used or interpreted in your painting to create the effect you want. It is important to use your imagination and let go of your reference materials as soon as possible; the idea is not to paint a replica of a photograph, but more to capture feeling and atmosphere.

Strelitzia

38 x 56cm (15 x 22in)

This exotic flower, known as the bird-of-paradise flower, is not the easiest to place in a composition. I eventually decided on this cropped version, as I loved the impact created by the blues and oranges in the centre of the painting, and the bold space shapes created by the spiky petals at the edges. I painted these using an even wash for emphasis.

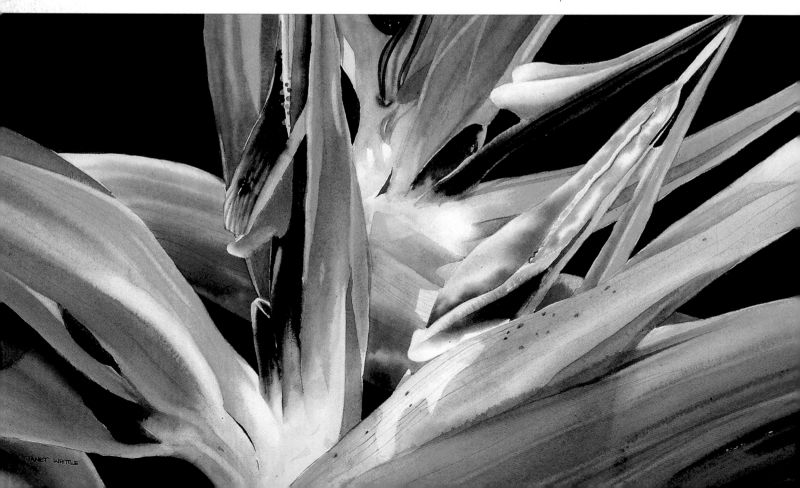

I use the wet-in-wet technique a large proportion of the time as this allows me to mix colours on the paper that go muddy when mixed in the palette, for example green and orange. As a general rule, more than three colours mixed together in a palette will also tend to go muddy. When working wet-in-wet, remember that the colour will spread and dry lighter, so take this into account when mixing the colours for your painting.

Generally speaking, watercolours can be divided into transparent, semi-transparent and opaque colours. Use a transparent colour to glaze with, then the colours underneath will show through. Almost all the colours I use are transparent, as I like the effect created by the light passing through them and bouncing back off the white paper underneath. If you choose to use an opaque colour, make sure you put it on in the initial washes, then you can use transparent colours over the top if you wish.

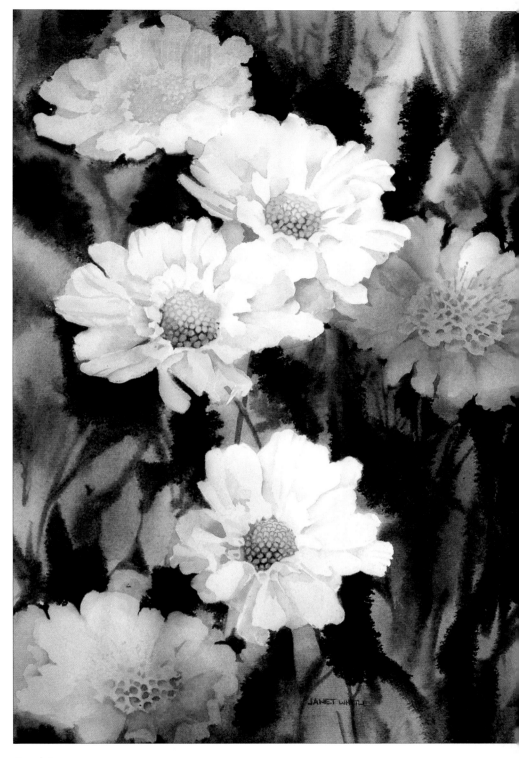

Scabious

38 x 56cm (15 x 22in)

I introduced purples and blues into the greens in the background and kept these soft so as not to overwhelm the delicacy of the flowers, some of which I kept out of focus.

Reds and pinks

When using reds, I often use a bright pink, such as opera, or a lemon yellow in the first washes, as reds on their own tend to dry flat. Having the pink or yellow glowing through gives the painting vibrancy. Pinks can be very cool when used all over a painting, so I often warm some areas with a glaze of aureolin.

Opera

A very vibrant pink that makes orange and peach mixes with quinacridone gold.

Winsor red

A slightly opaque, intense red which mixes well on paper with other colours.

Scarlet lake

Glazes well, and when dropped in over the top of lemon yellow gives a useful poppy colour.

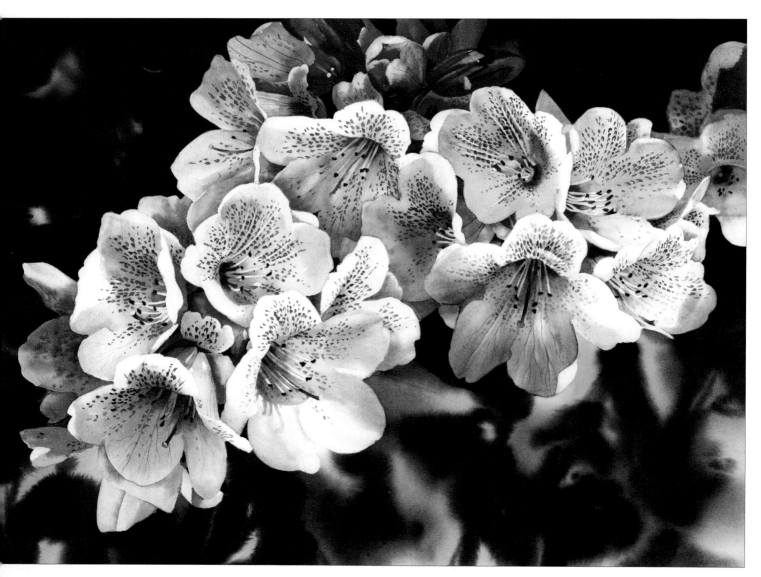

Firelight

53 x 38cm (21 x 15in)

This rhododendron is an absolutely stunning flower, with wonderful warm peach, red and pink colours. I enhanced these by painting the shadows in purples, keeping the background soft to avoid it looking fussy.

Quinacridone red

One of my favourite reds, I have combined it with opera in the painting on page 16 to give depth to the buds at the top of the picture.

Rose lake

Sometimes no other colour will do. A gentle, subtle red, but with a richness of its own.

Permanent rose

Not quite as bright as opera, but very versatile in mixes and glazes when slightly less vibrancy is needed.

Perylene maroon

A rich, deep transparent red. When mixed with viridian, it makes a wonderful olive green.

Iceberg Roses
25 x 46cm (10 x 18in)

I have used pink towards the centres of these roses, mixing it with cobalt blue and then helio turquoise to create a lavender colour, fading it into a deeper blue on the left-hand side of the petals. To unite the painting, I have used the same colours in the background. In the centre of the main flower I have created the impression of light bouncing from the parts of the petals immediately surrounding the stamens to warm the flower.

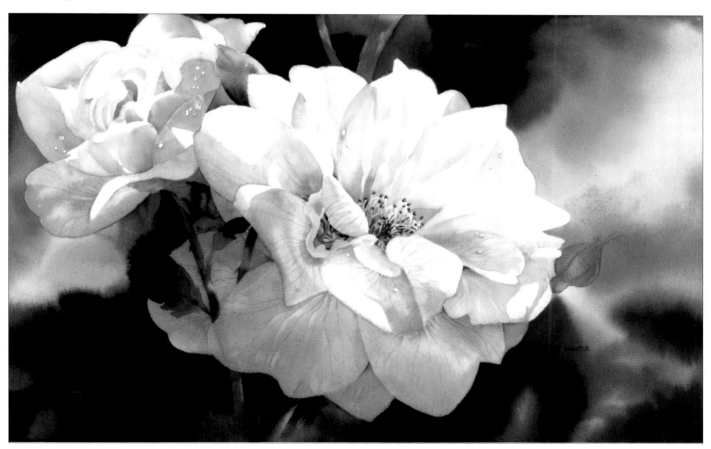

Yellows and oranges

Yellows have a very short tonal range, so I feel it is important to take some areas to white to have as full a range as possible, and hence give a painting depth. It can be difficult to add shadows to yellow as they can go muddy if overused. I often use quinacridone gold for depth and shadows, adding a little translucent orange to keep the vibrancy, and glaze these over a lighter wash.

Aureolin

Glazes beautifully. I often use it at the end of a painting to warm greens where I want to add richness.

Lemon yellow

Makes a wide range of greens when mixed with Winsor blue.

Quinacridone gold

When mixed with opera, this makes one of my favourite colours for flower centres as it is very transparent and retains its freshness.

Transparent yellow

Makes a wide range of greens, and flows well on the paper.

Translucent orange

Keeps its brightness, is wonderful for glazing when mixed with opera, and can be used for warming cool yellows.

Indian yellow

Slightly opaque, but a rich colour that does not lose its vibrancy. Useful for deepening lighter yellows.

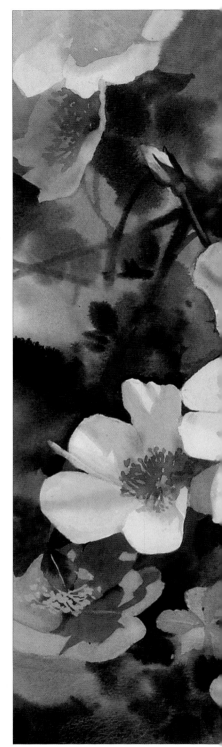

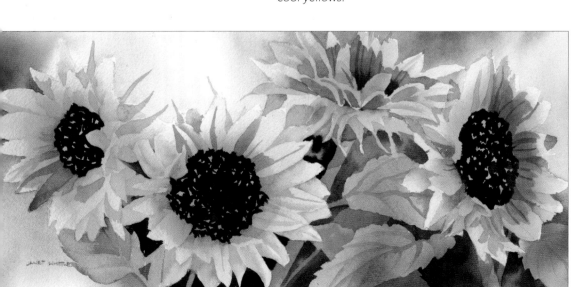

Sunflowers

38 x 24cm (15 x 9½in)

I chose this format for these sunflowers to focus interest on the wonderful flower heads.

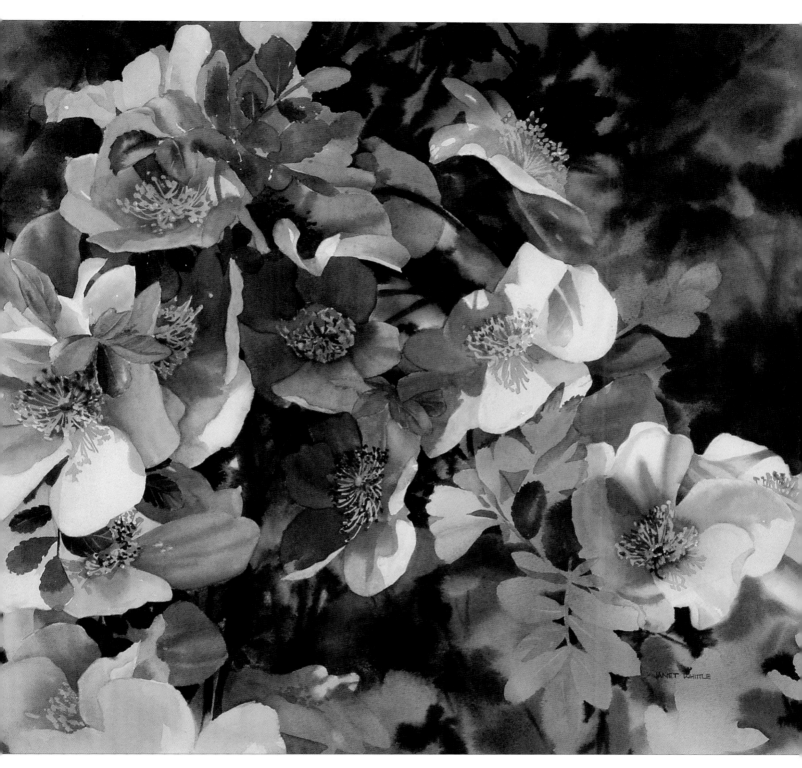

Canary Bird

53 x 38cm (21 x 15in)

When painting a collection of small flowers, I concentrate my attention on a few rather than adding the same level of detail to all of them in order to avoid the 'wallpaper effect'.

Blues and purples

Blues in flowers are often the same tone as the green of the leaves so, as with yellows, I leave some highlights using the white of the paper to give sparkle and depth. I use transparent colours so that I can emphasise the darks by glazing over more layers in the darker areas.

I have combined different-coloured flowers in the painting of irises on the right to emphasise the blues and purples and to contrast with the greens.

Cobalt blue

I use this a lot mixed with opera for shadows, and when mixed with yellow it gives a subtle green.

Winsor violet

A wonderful transparent colour, invaluable to the flower painter.

Helio turquoise

When mixed with viridian, this makes interesting variations of green.

Phthalo turquoise

Mixed with viridian, this makes a blue-green that I often use in background washes.

Indigo

A dark blue that I use instead of black, which dries flat.

Winsor purple

A lovely colour in its own right, and wonderful when working wet-in-wet.

Paris blue

Slightly different from Winsor blue, it is more intense and retains its brightness.

Indanthrene blue

Mixed with perylene maroon, it gives a rich, dark green.

Winsor blue

A tried and tested favourite with hundreds of uses. Makes wonderful greens and is very useful for glazing.

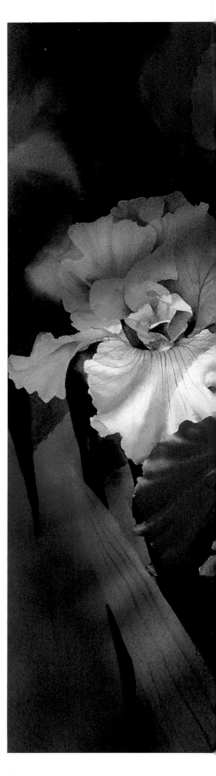

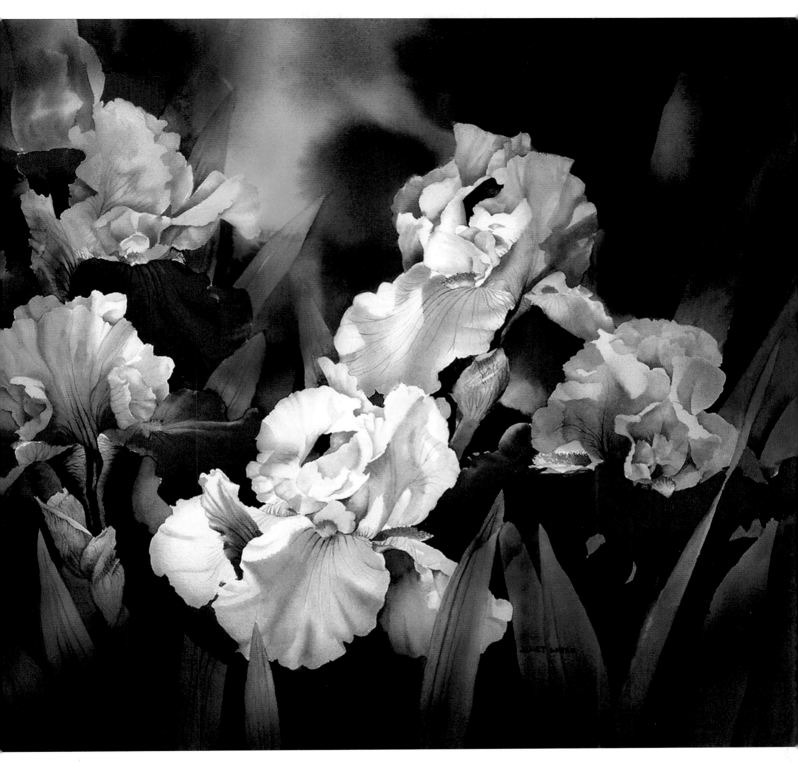

Jelly Roll and Honky Tonk Blues

51 x 38cm (20 x 15in)

Known as 'flowers of the rainbow' for good reason, when painting bearded irises I am spoilt for choice when it comes to colour, consequently they are one of my favourite flowers to paint.

Greens

Greens can go very grey and cold if they are not combined with more intense colours. Blues and yellows are good for this and I often drop two or three mixes in, allowing them to combine on the paper by tipping it, to give the painting a glow. Mixing them in a palette would result in dull colours.

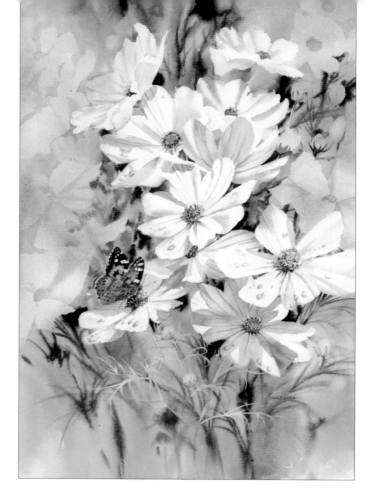

Cosmos and Painted Lady
30 x 51cm (12 x 20in)

Painted as a fountain of flowers, I have pushed the lighter ones back, cutting them out of the first wash so they remain in the distance, and painting in the butterfly to lead the eye into the composition.

May green
A slightly opaque spring green, works well in initial washes.

Viridian
Not often used on its own, but mixes with burnt umber or perylene maroon to give an olive green.

Helio green
Again, not often used on its own, but mixes well with blue for alternative greens.

Hooker's green
Very versatile, even on its own. Often used in landscape painting as well.

Winsor green
Mixed with blue, I often use it for painting in negative shapes.

Sap green
A bright spring green that mixes well. A good colour to drop in washes.

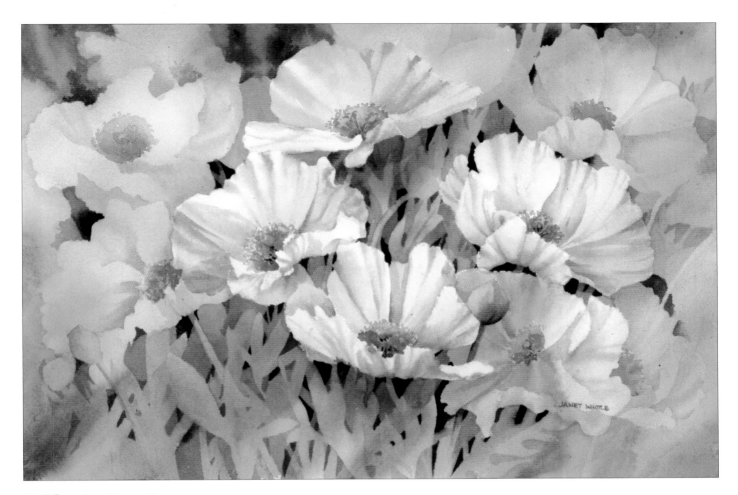

Californian Poppies
66 x 46cm (26 x 18in)

As delicate as white tissue paper, these beautiful flowers do not last long, so you have to be very lucky to capture them in photographs before they die. As they are white, you can introduce background colours to the petals for added effect.

Sea Ho!'
66 x 46cm (26 x 18

Sea holly grows on and near many beaches, loving the dry and sandy conditions. I produced this painting as a commission for friends as it grows near their beach hut in Norfolk.

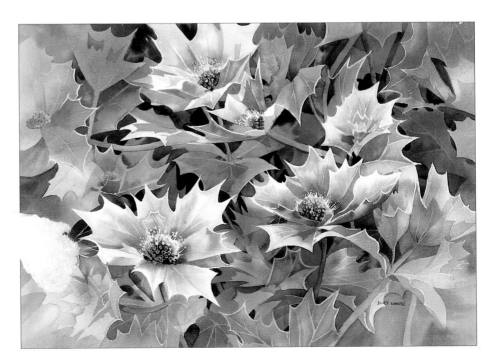

White flowers

I adore painting white flowers. It is a delight to paint the background in almost any colours I want to influence the mood of the painting, and the way they reflect off the petals to create areas of light and shade produces some wonderful effects.

I leave the white of the paper rather than use white paint, only adding colour to create the shadows and highlights.

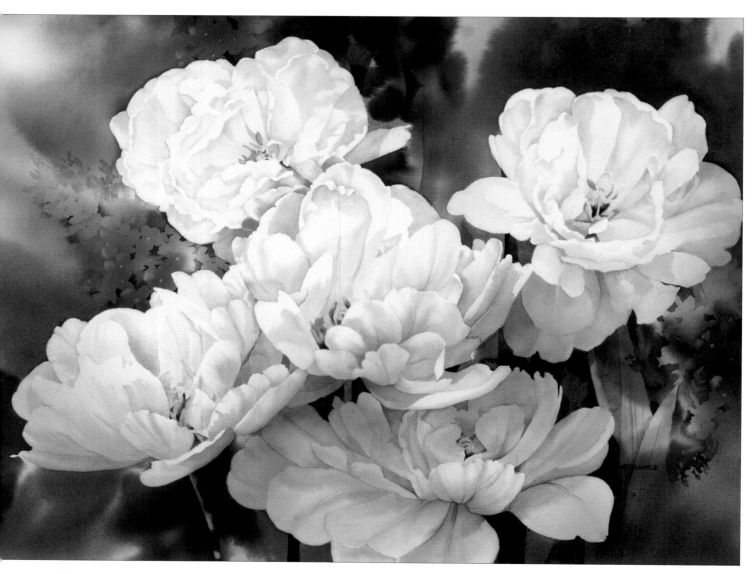

Tulips

51 x 46cm (20 x 18in)

These particular tulips are grown at Chenies Manor, Buckinghamshire where there is a wonderful show of spring tulips. We were lucky enough to go on a sunny day and I was able to collect a lot of reference photographs for use later that year. There is always a large amount of luck involved in photographing flowers, and for this reason I try never to be without a camera. There is nothing more frustrating than seeing a beautiful spring flower that you would love to paint, only to find that it has faded or died before you have had a chance to photograph it.

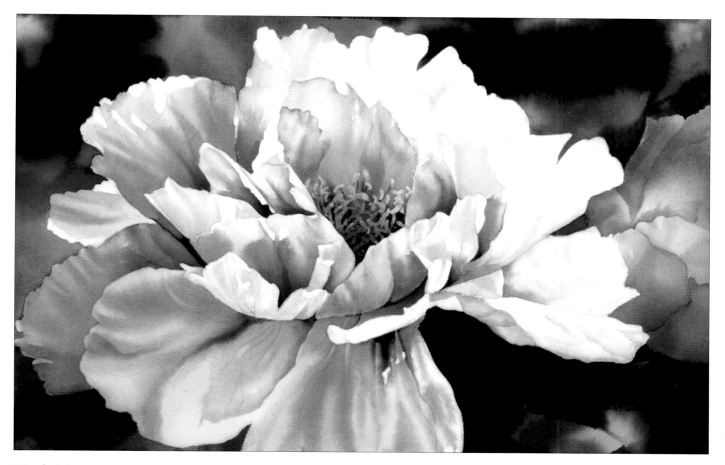

Godaishu
51 x 30cm (20 x 12in)

In this painting of a godaishu peony, the blues in the background have been allowed to bleed into the outer petals, so the flower does not appear too 'cut out'. I have suggested a background flower by painting around the first wash in a negative shape, using the greens.

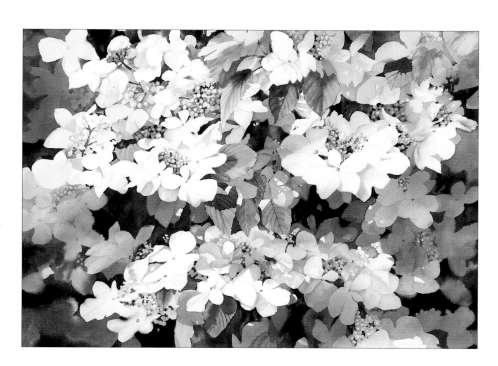

Lanarth White
71 x 46cm (28 x 18in)

I used a lot of blues and purples coupled with golds in these background washes, masking out only the white focal flowers of the hydrangea. I then painted darker areas behind the blue to bring out the other flowers from the background washes. The lace-like effect of these flowers is what captured my imagination. On close inspection, the tiny buds in the centres are exquisite.

Composition

Although I cannot overemphasise the importance of colour, as discussed in the previous section, one of the most important aspects of any painting is its composition. It is difficult, in my view, to achieve a good painting without starting with a composition you are happy with. Even if you change your mind as you go along, it gives you a far better chance of success if you have some initial ideas about how you wish your finished painting to look. Begin by asking yourself what the picture is going to be about, in other words what is going to be the main image in the painting. When you have decided this, everything else in the picture should complement it.

Always start by sketching out different compositions, and be prepared to adjust the positions of the various elements as you work. Do not be tempted to always place the main image in the middle of the painting with the other elements positioned evenly around it, shown in the top right-hand sketch, as this can be boring. Place it so that the surrounding negative spaces vary and lead the eye towards the main image. Remember that the shapes and sizes of the spaces at the edges of a painting are a very important part of your composition and should not be overlooked.

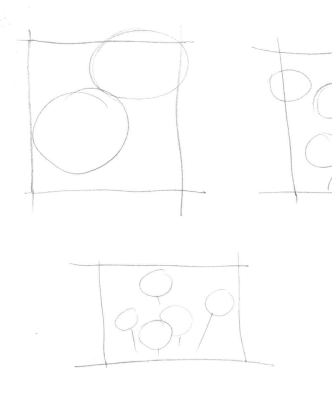

The various compositions I sketched out before settling on the one shown bottom right.

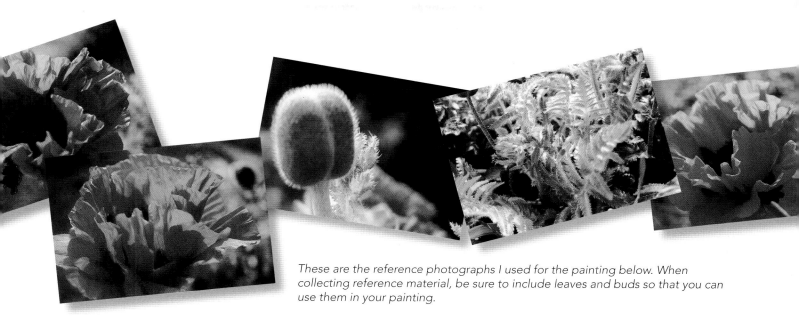

These are the reference photographs I used for the painting below. When collecting reference material, be sure to include leaves and buds so that you can use them in your painting.

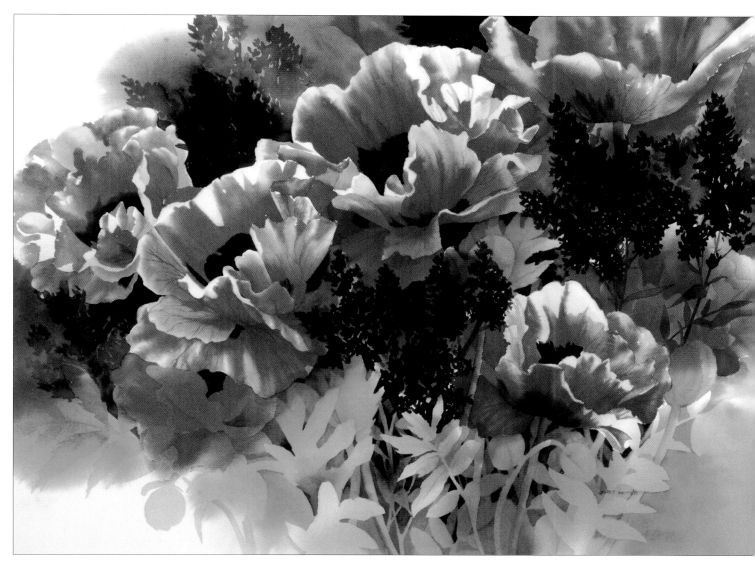

Oriental Poppies

71 x 51cm (28 x 20in)

One of the most popular flowers to paint is the poppy, and it's certainly one of my favourites. Here I have combined it with purple to complement the rich reds and oranges used for the petals, and have slightly vignetted the design.

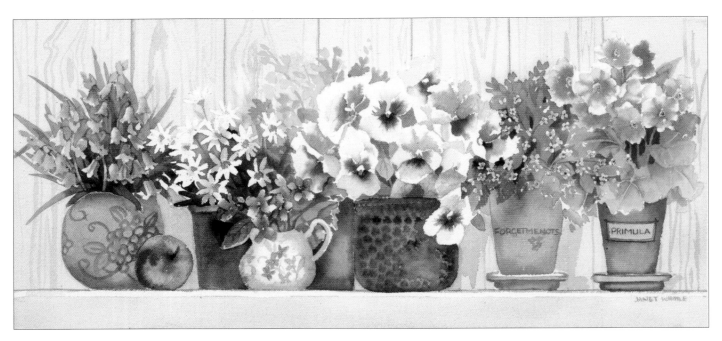

Shelf Life

51 x 24cm (20 x 9½in)

*An interesting compostion for a selection of
small flowers themed in blues and purples.*

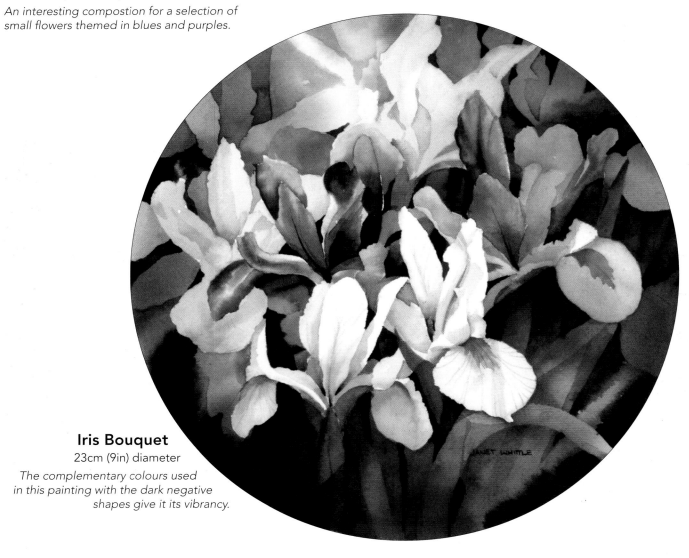

Iris Bouquet

23cm (9in) diameter

*The complementary colours used
in this painting with the dark negative
shapes give it its vibrancy.*

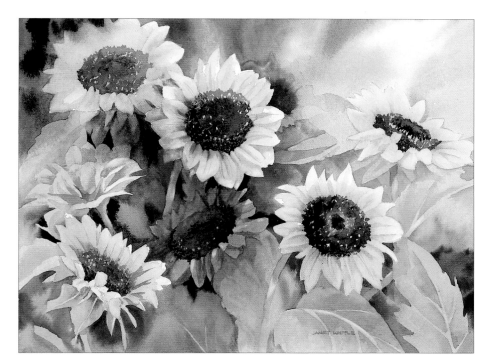

Sunflowers
36 x 26cm (14 x 10in)

Sunflowers are becoming increasingly popular and are easy to find reference material for. I have left the white of the paper showing through between areas of blue to depict shafts of sunlight. The gold of the right-hand flower is counterchanged against the white by darkening the gold of the petals (see page 50).

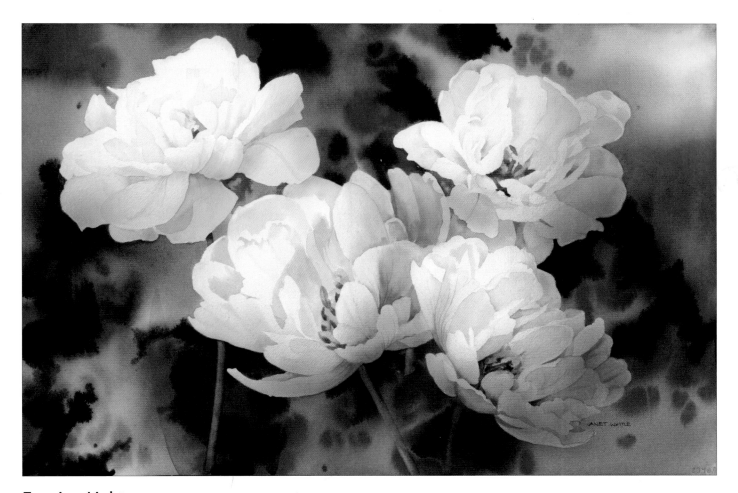

Evening Light
51 x 38cm (20 x 15in)

This was a very cool palette, so I decided to warm the flowers by using rich colours in the centres for contrast. The background is entirely wet-in-wet using two washes.

Combining different flowers

Combining different types of flowers can add another dimension to your painting. I usually combine no more than two species, making one the focal flower and the other secondary to it. Avoid adding too much detail to the secondary flowers, and make sure you leave some soft and 'restful' areas so that the painting is not too busy.

Flowers of very different shapes and sizes make for a more interesting composition, and I try to put together complementary colours, such as purples with yellows, and oranges with blues.

When combining different species of flower in a composition, it is a good idea to check and see if they flower at the same time of year. The same applies to other elements you might include in your picture, such as butterflies and foliage.

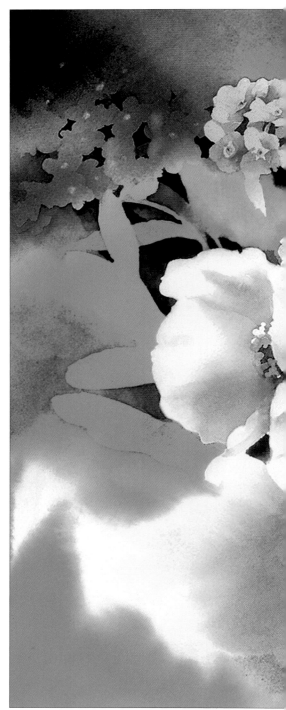

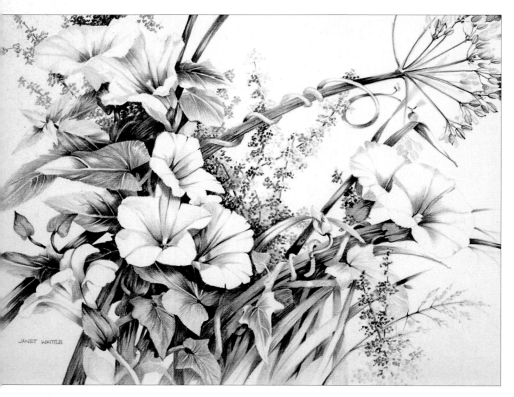

July Hedgerow
25 x 20cm (10 x 8in)
Convolvulus is a common climbing plant found in hedgerows and gardens, and its winding shoots and leaves are a delight to sketch.

Welsh Poppies
51 x 38cm (20 x 15in)

The sizes and shapes of the flowers are important in this painting. The forget-me-nots were easy to place in the background, where they add interest and variety, and their colour complements beautifully the golden yellow of the Welsh poppies. Some of the forget-me-nots are suggested shapes only with no detail. The negative shapes behind them were painted on the background wash, fading into the soft purples, greens and blues.

Still life

Painting still life is an excellent excuse for visiting bric-a-brac and charity shops, and can become something of an obsession. Don't worry if the item you like is chipped or damaged – this can be rectified in the painting. As well as flowers and fruit, I use a lot of glass, china and lace in my paintings. I also collect pieces of fabric, ribbons, some artificial flowers, baskets and anything else I find attractive.

As in any painting, less is usually better than more. First decide on the main focus of your painting, and then bring in other elements to complement it. Vary the sizes, shapes and textures of the objects, and overlap some of them to avoid too many gaps. Lighting is important and must be consistent, whether you are painting from photographs or from life. Use a small spotlight to create interesting shadows.

Maigold

51 x 38cm (20 x 15in)

This rose is a constant source of inspiration for me. It grows in my garden, so I have many reference photographs of it at different stages of development.

The objects in this composition vary in size and shape. I placed a single rose at the front to break up the space between the jug and the teacup, which are the same height, leaving a gap to the right of the jug to lead into the painting. The lace adds texture without being too fussy, and is reflected in the glass vase along with the stems of the roses and the gold of the foreground rose. I have added a glow of colour to the background to unite it with the table and add warmth, and bounced some colour on to the lace from the roses above.

Teapot and Roses

51 x 38cm (20 x 15in)

I found this old enamel teapot and the cup and saucer in a bric-a-brac shop. I loved the colours in the old patchwork skirt of mine that I used in the background, as they pick up the red of the teapot. Because the fabric I have used in this painting is rather intricate, I have kept the composition itself simple, spreading the colours and textures of the material into the background with a small amount of detail.

Drawing

If you have not painted a flower before, it is a good idea to do a pencil drawing of it first. This forces you to observe the flower's details, and gives you a better understanding of its shape and form. It also stimulates your imagination, helping you decide how you eventually wish to portray the flower in your painting. Keep your drawings for reference, and often they can be incorporated into a composition. Occasionally I draw some of the flowers and paint others, which can produce a very attractive effect.

As in paintings, tonal values may have to be altered in order to make a drawing work well. This is usually done at a late stage and requires confidence and a bold touch, though unlike a painting, mistakes made in a drawing can be easily rubbed out.

In general, if a picture works well as a drawing, it will also work as a painting.

The pencil outline.

Tip

Rest on a sheet of folded paper as you work to prevent smudging.

1. Using an HB pencil, put in the first tone. Use light, feathery strokes, working from the pencil lines outwards, following the natural direction of the petals. Maintain a comfortable position by turning the drawing as you work.

2. Continue working over the whole drawing, building up the initial tone.

3. Where two edges are very close together, first feather upwards from one edge towards the other.

4. Then feather downwards from the other edge so that the tones meet and blend together in the middle.

The drawing, with the first tone completed.

5. Change to a 3B pencil and start putting in the mid-tone, darkening areas of the picture where necessary.

6. Use dark cross-hatching along the length of the stalk.

7. Continue to lay the mid-tone into the stalks and the centres of the flowers. Aim to keep the edges of the flowers light, working behind them.

8. To bring the flowers forward, continue with the 3B pencil and cross-hatch the background areas. Cover some areas with lighter, single strokes.

The first and mid-tones completed.

Tip

Your work will smudge easily at this stage, so be careful when shading, and lay a piece of tracing paper over your work to rest your arm on.

9. Start applying the dark tones with a 9B pure graphite pencil, putting the darkest darks against the lightest lights to create areas of counterchange. Try to keep your strokes even to maintain a uniform texture.

10. Continue adding the darker tones.

11. Accentuate the centres of the flowers using fine strokes with a pure graphite pencil. Pull out some of the darks.

12. Using a 4B pencil, shade back the flower middles. Pull out some highlights from the flower centres using an electric eraser. Alternatively, use the point of a plastic eraser or a scalpel.

Tip

Create deeper tones by pressing harder with the pencil.

13. Start to deepen the tones where necessary. Leave the HB tones showing in some areas.

14. Continue to darken the background. Use cross-hatching where necessary using a 9B pencil.

15. Strengthen the edges of the picture, using a ruler if necessary, to help define the composition. Continue to deepen the darks using pure graphite.

16. Soften in the dark areas with a hard pencil – either F or H.

17. Spray the finished picture with fixative to preserve it and stop it from smudging.

The finished drawing.

Hollyhocks

35 x 25cm (14 x 10in)

Having finished the drawing and sorted out the tonal values so that they work, you are ready to produce your painting. Start by thinking about colour. I have dropped the flower colour into the background along with the light green and darker shades, and picked out the background flower and leaf shapes by painting in the negative shapes behind them, with no details. When you move on to painting the foreground flowers, apply the same tonal values as you used in your sketch.

Watercolour pencils

I use watercolour pencils wet-in-wet, dampening the paper first, and then stroking the colours on. This gives a softer and denser colour than when using the pencils on dry paper, and it can still be glazed over. To create a light wash, I scribble some colour on to an old piece of watercolour paper and wet it, taking the colour off with a paintbrush.

If using watercolour pencils dry, you need a textured or slightly abrasive paper or card to layer the colours (very similar to using pastels). For example, to create green, first lay on yellow, and then blue.

Oriental Poppies
21 x 29cm (8½ x 11½in)

To deepen the reds on this watercolour pencil painting, I have used three, sometimes four, layers. The darkest blues in the background and the middles of the flowers have been added last.

Firelight
29 x 21cm (11½ x 8½in)

I used watercolour pencil in the background of this painting. I first scribbled purple pencil on to a scrap of watercolour paper, then dissolved the colour in a palette and added it to the background wash.

Getting started

Below is a checklist of all the stages you need to go through to plan a successful painting. By following this list carefully, you can eliminate a lot of the factors that might cause your painting to fail simply because you have not prepared properly.

Checklist

1 Make sure you have enough reference material, either living plants or photographs; just one photograph or plant will probably not be enough.

2 Decide on the size and shape of your painting – is it to be round, square, letterbox-shaped, etc? Does the flower lend itself to a large or small painting?

3 What techniques are you going to use? Is the paper suited to those techniques? Will it take a masking fluid? Is it textured or smooth? I always stretch my paper to avoid cockling when the paper is dampened, unless it is 640gsm (300lb) or over.

4 Stretch your paper either using a paper stretcher or gummed paper tape. There is nothing worse than trying to paint on cockled paper.

5 Make thumbnail sketches to decide the position of the main flowers.

6 Be happy with your composition. You may get away with a mediocre painting, but not a bad composition, and you will spend a lot of time trying to rectify it later on. Take your time, and don't make do with something you're not totally happy with.

7 Remember to interlock some shapes to avoid 'holes' in your composition, and vary the sizes of the different elements. Include buds, flowers at various stages of opening, and different-sized leaves, and push some elements into the background for more depth.

8 Draw a border around the composition area. This helps you visualise the composition as you work, and enables it to go under a mount.

9 Transfer your image to the paper. You may want to draw in other elements later after the washes have been applied so that they don't disappear (do this with a softer pencil so as not to dent the paper). Attach your paper to a drawing board using masking tape.

10 Decide on your palette, allowing it to reflect the mood of the painting.

11 Think about whether you wish to mask anything out straight away, or to lay a background wash first.

12 Stand back and check that your composition is what you want. Is it balanced? Should you add more elements, such as background foliage, or an extra flower? Take your time over this – everything needs to be right at this stage as mistakes can be very hard to rectify later on.

Paper stretching

The easiest way to stretch paper is by using a paper stretcher (see page 13). First dampen your sheet of paper by immersing it completely in water to make sure it is evenly soaked. The amount of time you leave it in the water depends on its weight – 640gsm (300lb) paper will need two to three minutes, whereas 190gsm (90lb) paper will need only one minute. Place the paper on the baseboard, clamp it in the frame and increase the tension until the paper is flat. Allow the paper to dry, then simply begin painting.

Alternatively, you can use the old-fashioned gummed paper tape method. First tear off four strips of gummed paper tape, minimum width 5cm (2in). After soaking the paper, lay it on a drawing board and wipe off any excess water with a teatowel. Run the tape through water and remove any excess by pulling it between two fingers, then lay it along the sides of the paper, half on the board and half on the paper. Press down lightly and leave the paper to dry flat. For larger sheets, use a trigger tacker over the gummed paper tape to make sure it stays down. When you have completed your painting, remove it by running a craft knife or scalpel around the edge of the paper, using a steel rule as a guide.

Transferring a design

Start with your design drawn on to cartridge paper. Go over it in ink and photocopy it. Always put as little detail into your line drawing as you can, and avoid shading; you can add detail later, needing only a simple basic outline to begin with.

1. Turn the paper over on which you have photocopied your design and rub it all over with a pure graphite pencil (or a soft pencil). Go in one direction first and then the other to make sure all of the picture is covered evenly.

2. Turn your design over and position it on your sheet of watercolour paper. Hinge it at the top with masking tape.

3. Draw over the outline with a red biro (so that it shows up), pressing fairly firmly.

4. The design will be transferred to the watercolour paper.

Techniques

There are a number of basic techniques that I use in my painting, though I avoid incorporating too many of them in a single piece of work. Different techniques suit different flowers and compositions, and the secret is to imagine which would work best in your painting to achieve the desired effect. I have included the techniques I use most and that I know, by experience, work well, so that you can practise them and decide for yourself when and where to use them.

Putting in a background

This is how I prefer to start my paintings, as it allows me to judge more easily the tonal values of the flowers I need in order to create depth. First, though, I usually apply masking fluid around the main part of the composition to avoid the background colours running into it. I am constantly experimenting and changing the techniques I use, but my basic approach to putting in a background is as follows:

1 Choose your colours and mix more than you think you will need as these will also be used during the rest of the painting.

2 Decide if the background will be applied in one or two washes, one light one darker, and whether you need to mask out at this stage.

3 Dampen the paper and, starting with the lightest colour, load your brush and drop the paint on to the paper. The paint must spread away from the brush easily but not uncontrollably – if the paint stays in one place your paper is not damp enough, and if it spreads too much it is too wet. You need to achieve a good balance between the two.

4 Drop in your other chosen colours, gradually working towards the darker shades. If any areas start to dry out, redampen them using a fine water spray. Pick up any excess droplets using the tip of a damp brush, without touching the paper.

5 When you feel you have applied enough colour, tip the board to allow the colours to mix on the paper and allow it to dry flat. You can speed up the drying process using a hairdryer, but allow the shine to go off first otherwise it will spread and dull the colours.

6 If you are unhappy with the end result when it has dried, you can redampen small areas using a fine water spray and add more colour. Of course, you can take more drastic action and wash off all the paint before it dries and start again!

Choosing your background colours

The colours you use in the background will depend on the colours of the flowers in the composition. I often use the same colours in the background as I use in the foreground flowers so that I can turn areas of the background into flowers later on. This also gives the painting a sense of unity. Remember that watercolour dries lighter, and working wet-in-wet diffuses the colour, so work fifty per cent darker and brighter than you want the finished result.

I brighten greens by using yellows and blues, as greens can dry flat on the paper. I leave some of these colours unmixed in some areas to vary the tonal values, which makes a more attractive painting. Any areas that are too bright can be glazed back with a wash later if needed. I tend to work brighter than I intend the finished result to be, as you cannot retrieve brightness once lost, but it is easy to calm an area down using transparent washes. Occasionally I use an airbrush for this so as not to disturb the paint underneath.

In the four examples on the left, you can see the difference between the foreground flowers and the slightly more subdued mid-ground flowers – the result of applying two washes, then the darker negative shapes on top. To achieve really dark tones can take up to three layers in watercolour, so be patient.

Magic Man and Marmalade Skies

71 x 61cm (28 x 24in)

The colours of these irises have been chosen to complement each other, fading to warmer colours in the background. I have used wet-in-wet to create the soft shapes of leaves in the background, and the overall out-of-focus effect adds depth to the painting.

Masking out

Smaller flowers, such as the ones in the picture on page 47, should be masked out before putting in a wet-in-wet background. You then avoid having to work around the detailed outline. In this particular painting I have masked out twice. First of all I masked out the lighter bluebells in the middle of the composition and then put in a wet-in-wet background using blues, greens and golds. After letting this dry I masked out the secondary bluebells over the first blue wash, dampened again and then dropped in more colour to bring these out. For this technique to be successful, you must ensure that the masking fluid you use doesn't lift off paint when removed, otherwise it will leave a line around the secondary flowers.

With larger flowers and a more simple outline, it is not necessary to mask out. Paint only spreads where there is water, so if you wet the background up to the pencil line, the paint will not go beyond that.

Apply masking fluid using an old paintbrush. Paint it on in a continuous line around the shape you wish to mask out, keeping just within the pencil line.

Tip

When dampening the paper for the background wash, make sure the water spreads right up to the line of masking fluid or you will be left with a halo of white around the flowers.

Lifting out

Mistakes in watercolour painting can often be corrected with a little patience. Paint will lift off quite easily by rubbing the area gently with a damp acrylic brush or an electric eraser. Small, definite shapes can be removed by dampening the area first with clear water, rubbing it with a damp acrylic brush and then blotting with a piece of absorbent paper towel. Staining pigments will not be removed completely, but can be painted over with a darker tone or, in some cases, white acrylic paint. Some papers allow you to lift out colour more easily than others, and beginners should experiment with different paints and papers to find out which ones are best suited to this technique.

Lifting out is also an extremely useful technique in its own right, not simply for correcting mistakes. I use it for softening the edges of flowers etc. and putting in stalks. I also use it for removing areas of green in the background and then glazing with aureolin to depict sunlight.

Another way of taking out colour is by going up to the edge of the wet paint with clear water and allowing the pigment to bleed into it.

Bluebells and Tortoiseshell Butterfly

23 x 23cm (9 x 9in)

There are many lovely bluebell woods near my home and I am often inspired to paint these beautiful flowers. I sometimes combine them with other spring flowers that are out at the same time. The butterfly is the focal point of this painting, and it is complemented by the colours and size of the flowers. I have lifted off small areas of sunlight on the stalks and leaves and glazed over them with aureolin to brighten the painting. This can also be done with a sharp scalpel for tiny pinpoints of light.

Wet-in-wet

For me, the technique of wet-in-wet represents the magic of watercolour painting. With a little practice, it will make your paintings appear fresher and less overworked. Watercolour paper is manufactured to allow paint to float and mix on its surface when it is wet, providing the painter with the opportunity to create an endless variety of colour and tone combinations. You can control this process by varying how wet you make the paper, and the density of the pigment you have mixed. If the result isn't exactly how you imagined, it can be rinsed off and repeated, or you can allow it to dry and start again by wetting it gently.

Paint applied wet-in-wet should leave the brush easily and bleed across the paper.

Place lighter colours first, adding darks later in small amounts and using denser pigments to avoid them spreading too far.

Tip

When paint is applied wet-in-wet, it will diffuse and dry lighter, so work fifty per cent darker or brighter than you want the finished result. Areas can be glazed back later if they are too bright, but if you lose vibrancy it is very difficult to retrieve.

Wet-on-dry

Applying wet paint to a dry background allows you to produce sharp edges. Towards the end of a painting, you can use the technique to add details, to emphasise the focal flowers or to paint in small negative spaces. Most people, particularly beginners, feel happier with this technique than with wet-in-wet as they feel more in control, but don't make the mistake of overusing it because of this.

There are times when what you do in the last ten minutes of a painting will make or break it, but if a painting simply isn't working it is better to have the courage to try and improve it than to settle for a mediocre end result – and you will learn more from it in the process!

Hard and soft edges

It is important to have a good balance of hard and soft edges in your painting. Too many hard edges can make it look harsh and overworked. At first, try to keep as many soft edges as possible using the wet-in-wet technique, then towards the end assess whether any parts need sharpening. For a more controlled soft edge, for example within a small shape such as a petal, paint the deeper-toned area first, then paint up to the edge of the colour with clear water and allow it to bleed forward.

When you have painted on your background and removed the masking fluid, the flowers can look 'cut out'. The best way to rectify this is to soften the edges in some areas using a damp acrylic brush. Work from the white paper towards the paint, gently removing the hard outline, being careful to just go into the very edge of the paint.

Softening a hard edge using a damp acrylic brush.

Rhododendron

71 x 24cm (28 x 9½in)

The leaf shapes in this background have been dropped in using wet-in-wet, carefully controlled so that they don't disappear into the other background colours. This technique takes a little practice to master, but is a very effective way of adding interest to an area without including detail.

Negative spaces

Negative spaces are the spaces between the main elements on the page. They are the shapes in the background, behind the leaves and flowers.

By painting in the negative spaces, you can make leaves and flowers appear in the background, and then add details to them such as veining. This is a way of producing simple background images that do not overwhelm the foreground flowers, and I use this technique in the majority of my paintings.

Putting in the negative spaces between the leaves draws them out from the background and brings them to the foreground of the painting.

Himalayan Poppies
71 x 51cm (28 x 20in)

As this is such a large painting I masked out the edges of the flowers and the stamens before putting in the background washes. I kept the left-hand side lighter to depict a shaft of light. After the initial green background wash, I brought forward the leaves and stalks by painting the negative spaces between them. Within these negative shapes I painted more leaves and stalks to create a three-dimensional effect.

Blues can be very similar in tonal value to greens, so I have bled the blues out to white at the edges of the flowers. This technique, of placing the darkest darks next to the lightest lights, is known as counterchange, and is an excellent way of adding vibrancy to a painting.

Veining

There are several ways of tackling veining, depending on the type of flower or leaf you are painting, and whether the veins are light against a dark background, or dark against light. For light veins, you can paint the negative spaces in between them over an initial wash, masking out the veins first if necessary. For darker veins, use a small rigger and paint them in, following the curves of the leaf or petal, moving outwards from the centre to the edge. A rigger has longer hairs than a normal brush and therefore holds more paint, so you can paint long veins in a continuous stroke without having to reload the brush with paint. I then darken the veining within the shadows.

Plants exhibit many different veining patterns, but generally they are thicker towards the middle of the petal or leaf and fainter towards the edges, splitting into several smaller lines, or fading into the light altogether.

Tip

Do not add veining to every petal as it will overwhelm your painting, and is not needed on background flowers. Too much detail will bring them forward and make the composition confusing to the viewer.

Adding lighter veins to a leaf by painting in the negative shapes using wet-on-dry and then bleeding them out with clear water.

Painting on darker veins using a rigger.

Maigold
40.5 x 30.5cm (16 x 12in)

Drawing a flower always gives you a better understanding of how it is formed. It is also a good chance to practise the folds in the petals and observe the leaves.

Folds in petals

Folds in petals create a shadow or at least a darker tone, so look for the changes in tone and paint it in using either a deeper mix of the flower colour, or a shadow mix. The mix used here is cobalt blue and a touch of permanent rose and, for darker shadows, cobalt blue and a touch of light red.

There is no need to suggest every fold on every flower. In general, apply less detail to background flowers than to those in the foreground, as this will emphasise the three-dimensional feel of the painting and give it depth.

The only colour on these white flowers, apart from the golden centres, is due to the shadows created by the folds in the petals. These I have painted on using a mix of cobalt blue and a touch of permanent rose.

JANET WHITTLE

Vignetting

A vignette is a painting in which parts of the background fade to white. The painted area should touch the sides of the paper in three places and consist of some hard and some soft areas. It is an interesting type of composition and suits some flowers very well. It is also used in landscape painting.

In a vignette, you need to think beyond placing the main flowers in the centre with the background elements arranged evenly around the outside; the white spaces at the edges of the picture are just as important as the painted area, and need to be designed with as much care.

Vignetting is often used in sketches as it reduces the amount of background that has to be pencilled in. The white of the paper creates an attractive design with little effort.

Poppies and Corn
40.5 x 30.5cm (16 x 12in)

As with paintings, I shade negative spaces between stalks and leaves to create depth. Note the various angles at which each side of the vignette touches the edge of the paper.

In the painting below, I have simplified some of the detail and used colour for variation instead, keeping the basic composition the same as in the original pencil drawing above.

Glazing

This is an invaluable technique that I use towards the end of a painting for warming or cooling areas. Make sure you are not using a paper which paint lifts off easily, otherwise you may disturb the initial washes, making them muddy and streaky. The best results are achieved with transparent colours – two of my favourites are cobalt blue to cool background shapes in order to accentuate the focal flowers, and aureolin to brighten and warm leaves and stems.

Make sure the painting is completely dry before using this technique, and glaze with as few strokes as possible using a watery mix of colour and a large brush.

These two pictures show the effect of adding glazes to your finished picture. In the lower one, a glaze of indanthrene blue has been laid over the purple petals, the greens have been strengthened using helio turquoise and Hooker's green and the yellow petals have been glazed with aureolin.

Shadows and sunshine

Shadows can make or break a painting. Done well, they can add another dimension to a painting and create something very special. They are often darker than you may at first have thought, and it can take courage to put them in sometimes, but without them it is impossible to depict sunshine falling on petals, which is an integral part of my style.

Shadows give depth to a painting, and darker shadows give the illusion of bright sunshine. The colours I use are either a darker mix of the flower colour, or a combination of blues and reds to create a blue-grey shadow mix.

Cosmos Seashells
51 x 38cm (20 x 15in)
The flowers in my reference photograph grow in my garden and are actually white. By observing them at different times of the day I was able to capture the effect of the evening sun falling on their petals, coloured by the reflected purples from the surrounding plants. As a contrast to the main flowers, I masked the tiny purple flowers over a background wash to add some texture to the soft, wet-in-wet areas, and kept the leaf fronds soft and simple.

Make sure your reference photographs include shadows by taking them in sunlight, and all from the same direction so that the light source is constant. Painting from life is very difficult because the light is always changing as the sun moves across the sky. Evening shadows are wonderful, as are those cast first thing in the morning when they are at their deepest.

Godaishu Peonies
71 x 58cm (28 x 23in)

I allowed the first background wash of paler turquoise and greens to bleed into the flowers from the left-hand side to set them in the picture, then masked the edges when dry before applying deeper colours. Shadows are often a lot darker than at first thought so glazing over some areas is vital to achieve the correct tonal value. I masked the centres of the flowers for the first wash and then glazed the details back with translucent orange and permanent rose, adding some colour bounce to the surrounding petals to warm them. I have exaggerated the darks within the petal shapes and left the paper white to catch the effect of bright sunlight coming from the right.

Blue Hydrangeas

73 x 48cm (29 x 19in)

The flowers and the jugs were photographed separately for this particular painting and composed later. I have painted the light coming from the left. I particularly enjoyed the reflections on the jugs and fruit and have bounced the rich reds of the apples on to the jugs and white cloth. As the flowers are intricate, I used a simple lace cloth which I pushed back with the shadow colour to emphasise the sunlight falling on the flowers.

Tulips

In the reference photographs for this painting, there are forget-me-nots in the background. I have chosen not to include them, instead painting an abstract background of blues and greens using the wet-in-wet technique. You could, if you chose to, put the background flowers in later by masking over the first wash.

As the main focal flowers are a creamy white, you can choose any background colours you wish, so don't be afraid to experiment.

This is a good exercise for practising hard and soft edges. Paint the petals at the back first, starting with pale yellow and using darker greens to reinforce the colour in some areas and give the flowers form. Bleed the yellow out to white at the edges of the petals, and make a hard edge along the top of the petal in front. This may sound a little complicated to begin with, but after some practice you will be able to do it easily.

The pencil drawing.

The reference photographs.

60

You will need:

HB pencil

Plastic eraser

300gsm (140lb) NOT paper, approximately 33 x 25cm (13 x 10in)

Drawing board

Masking tape

Masking fluid and old paintbrush

Paintbrushes (Nos. 4, 6, 7 and 20)

Flat acrylic brush

Paper towel

Two water pots

Palette for mixing

Viridian Helio green Paris blue Cobalt blue

Perylene maroon May green Aureolin

1. Draw the outline sketch and mask off the edges of the paper using masking tape. Apply masking fluid along the outer lines of the drawing and allow it to dry thoroughly. Make sure you keep the masking fluid just within the pencil outline.

Tip

Mix all the colours you will need for your background before wetting the paper.

2. First make the dark green mix ready for use later using helio green and perylene maroon. Wet the background up to the line of masking fluid using a large, No. 20 paintbrush or similar.

3. Change to a smaller, No. 7 brush and start to apply the background colours. Apply the blues first, starting with the lightest and then working in the darker tones.

4. Next drop in the greens, using viridian and helio green. Again, start with the lighter tones and finish with the darker.

Tip

Work quickly when applying the background washes, and allow the colours to spread naturally into each other.

5. Finish with the dark green mix you made in step 2. Tip the board to merge the colours and obtain a softer look. Lay the painting flat and allow the background to dry.

6. Remove the masking fluid by rubbing it gently with your finger, and rub out the pencil outline with a plastic eraser. Soften the edges of the background using a dampened, flat acrylic brush. Blot with paper towel as you go along.

7. Put in the yellows and greens on the petals, working wet-in-wet and using a No. 7 brush. First, make a mid-green mix of May green and aureolin. Dampen the paper and add a touch of yellow to one of the petals. Go a little darker with the mid-green, and finally apply a little of the dark green mix you used for the background.

Tip

When you begin a painting, refer to your photographs constantly as you work. As you progress, begin to let go of your references and start to depend more on your own imagination.

8. Do the same on all the petals, starting with the larger ones and ending with the smaller. Try to work from the back of the painting towards the front. Start to add in little bits of the background between the flowers (the negative shapes) as you go along.

9. Lay the first wash on the leaves at the bottom of your painting. Use a blend of mid-green, dark green, yellow and cobalt blue.

10. Put in the stamens using mid- and dark green. Work wet-in-wet.

11. Working on dry, put in the anthers using perylene maroon.

Tip

Brush away the fragments of rubber left on the painting with a large make-up brush.

12. When the painting is completely dry, remove as many pencil lines as possible using the plastic eraser.

13. Change to a smaller, No. 4 brush and bring out the focal flower by deepening the background flowers behind it. Use the dark green mix, laying a clear water glaze first for a softer finish.

14. Darken towards the centre to give the focal flower more form.

15. Put in the negative shapes behind the leaves using the dark green mix.

16. Add some blue to the shadows to deepen them using a No. 6 brush.

17. Assess your painting and remove any remaining pencil lines. Glaze over the shadows to soften them if necessary, accentuate the details in the centres of the flowers and on the leaves, add some veining to the leaves and petals using the tip of a small brush, and soften any hard edges.

Tulip
71 x 61cm (28 x 24in)

When observed closely, the centres of flowers are fascinating. By cropping in closely and focusing on the detail within the centre of a flower, the result can be stunning.

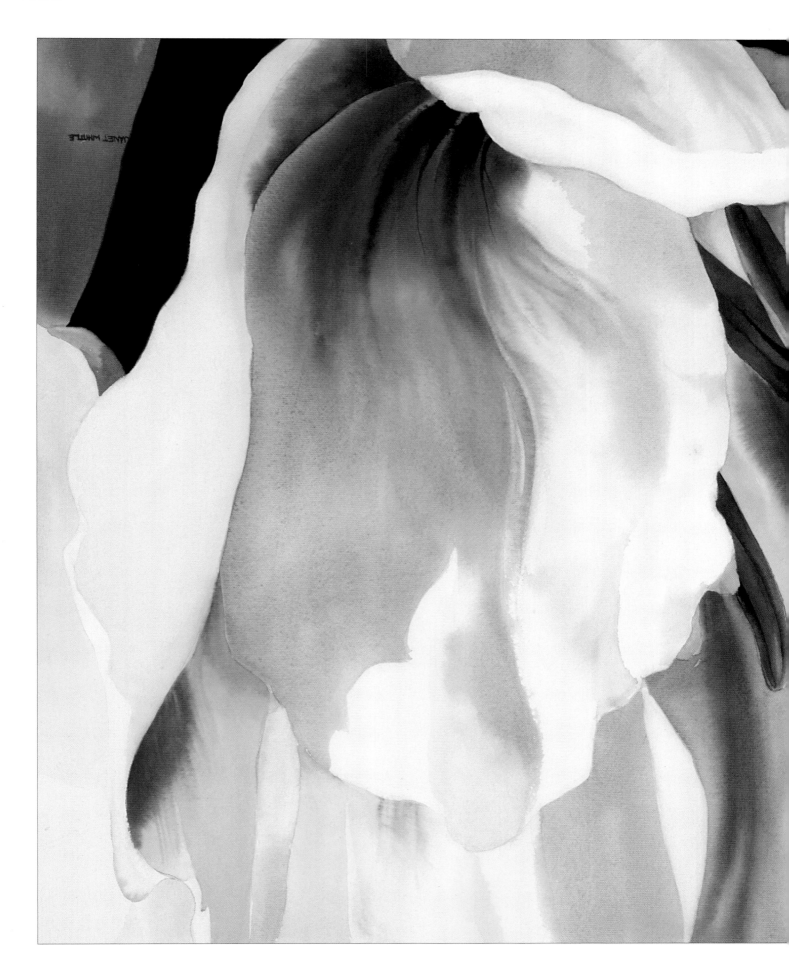

Roses

This painting has a slightly more detailed background than the tulips composition on pages 60–61. I cut out the leaves from the first background wash, leaving some of them light against dark, and later painted others dark against light. With the light coming from the left, the main areas of shadow, and also of counterchange, are on the right.

As the flowers in this project are white, this is a good exercise in painting shadows. Be bold in your application of shadows as they are often darker than you imagine in places. They add mood and atmosphere to a painting, as well as giving it depth. Consider intensifying the shadows even where in reality they are relatively weak.

The colours on the petals come mainly from the background, and I have warmed the centre petals of each flower to reflect the golden glow of the stamens.

The pencil drawing.

JANET WHITTLE

The source photographs.

You will need:

HB pencil

Plastic eraser

300gsm (140lb) NOT paper, approximately 33 x 25cm (13 x 10in)

Drawing board

Masking tape

Masking fluid and old paintbrush

Paintbrushes (Nos. 3, 7, 8 and 20)

Flat acrylic brush

Paper towel

Two water pots

Palette for mixing

Viridian	Paris blue	Cobalt blue	Helio green	Perylene maroon
Opera	Translucent orange	Winsor violet	Aureolin	Helio turquoise

1. Apply masking fluid around the edges of the main flowers and on the stamens, and allow it to dry thoroughly. Keep just within the pencil outline.

2. Mask off the edges of the pencil sketch using masking tape. Make a dark green mix using helio green and perylene maroon, and dampen the background using a No. 20 brush.

3. Using a No. 8 brush, drop in the background colours, starting with the blues and then the greens. Drop in the lighter tones first and then the darker ones.

4. Drop in a little pink, orange and violet to reflect the colours you will be using to paint the flowers.

5. Tip the board to merge the colours and allow the background to dry completely.

6. Paint in the negative shapes behind the background bud and leaves, starting on the right-hand side of your painting. Dampen the paper first with clear water then drop in viridian and Paris blue using a No. 7 brush.

7. When you have completed the right-hand side of your painting, start on the lower left. Begin by dampening the paper and then drop in viridian and Paris blue as before, cutting out the leaves.

8. Delicately paint in the leaves in the top left-hand part of the picture using Paris blue. Allow the background colours to dry.

9. Bring out the background bud on the right. Begin by applying cobalt blue and violet using wet-on-dry. Soften out towards the edges with clean water.

10. Build up layers of paint, softening each one with a gentle wash of clear water and allowing it to dry before moving on to the next.

11. When the background washes are complete, rub off the masking fluid. Brush away the rubbings using a soft make-up brush.

12. Soften the edges of the flowers using a flat acrylic brush.

13. Using a No. 7 brush, dampen the area in the centre of the main flower in preparation for painting the yellow glow.

14. Drop in opera and translucent orange.

15. Soften the hard edges by holding the board at an angle and brushing on clean water. Take the water up to the edge of the colour so that the pigment bleeds into it, creating a soft edge.

16. When dry, reinforce the colour in the centre of the flower using opera and perylene maroon.

17. Add a clear water glaze to the centre of the lower flower and paint it in the same way as the first. Allow the paint to dry.

18. Mix cobalt blue with a little violet for the shadows. Begin with the petals lying behind the front petal on the first flower, applying the shadow mix over a clear water glaze. Use a No. 7 brush.

19. Apply shadows to the other shaded petals in the same way.

20. Continue building up the shadows, accentuating the folds in the main petals and making the second rose stand out by placing a shadow behind it. Leave to dry.

21. To add interest, paint the centre of the middle flower using translucent orange and aureolin. Soften with a damp brush and allow the paint to dry.

22. Continue adding the shadows and softening out, using wet-in-wet.

Tip

Never paint lines. Use changes in tone to define edges, for example where petals meet.

23. Add a very dilute green to the shadow mix at the edges of the roses to reflect the background colour.

24. Continue adding the shadows, softening them where necessary with a clear water glaze.

25. Strengthen the colour in the centre of the middle flower using opera and translucent orange.

26. Add in any remaining leaves that you may have missed using viridian and Paris blue.

27. Deepen the centres of the flowers with touches of aureolin and translucent orange.

The completed shadows.

28. Rub off the masking fluid from the flower centres and remove as many pencil lines as you can.

29. Using a No. 3 brush, lay a glaze of aureolin over the central part of the upper and lower flowers.

30. Add a touch of perylene maroon to the tip of each stamen.

31. Using the No. 7 brush again, darken the inner part of the middle flower using perylene maroon. While the paint is still damp, deepen the tips using the dark maroon mix.

32. Darken the areas in between some of the stamens (the negative spaces).

33. Put in the bud using helio green and then the dark green mix.

34. Add further shadows to the middle flower where needed.

35. Separate the leaves by adding dark green in the negative spaces using wet-in-wet.

36. When you have darkened the areas around the leaves, start to put in the green stalks by painting the negative spaces behind them.

37. Add dark green to the leaves where they are next to the flowers to bring out the petals' edges.

Tip

If necessary, take out colour by going up to the edge of the paint with clear water and allowing the colour to bleed into it.

38. Continue to define the leaves. Work the darker background leaves first and end with the lighter ones in the foreground. Complete the stalks at the bottom of the picture. Rub out any remaining pencil lines and allow the painting to dry.

39. Mix perylene maroon, helio green and Winsor violet to make a very dark green. Place this mix next to the lightest lights to create areas of counterchange, enhancing the three-dimensional feel of the painting. Apply the paint over a dampened background.

40. Place the dark mix around the stalks, the main flower and in the top right-hand corner of the painting.

41. Above the upper flower, drop in helio turquoise and viridian. Use the same dark blue mix in the bottom right-hand area of the picture to suggest branch shapes. Apply the paint using wet-in-wet.

42. Add the darks to the bottom left-hand part of the picture, and allow the paint to dry.

43. Using cobalt blue and the dark green mix, add the background dark to the top left-hand part of the painting, adding emphasis to the lighter leaves in the foreground.

44. Use the dark blue mix to define the leaves in the blue areas of the background.

45. Add in more leaves and some buds using the dark green mix.

46. Finally, strengthen the shadows on the middle flower so that the upper one stands out more.

The completed painting.

Wild Roses

51 x 46cm (20 x 18in)

A delicate painting, capturing the fragility of the flowers with pale washes of pinks and blues. The background flowers have been pushed back and kept soft with as little detail as possible, so the eye is focused on the five or six blooms in the foreground. To achieve this effect, create an initial wash of pinks and blues, along with some of the green, and then paint the background flowers in behind a second wash.

Fuchsias

Fuchsias come in an endless variety of colours. They need a slightly different approach to composition from more commonly shaped flowers as they hang below the stem. In this project I have chosen a circular composition without too much foliage as the flowers are fairly small and, unless enlarged, would be lost in a bigger painting. I have painted simple leaf shapes in the background to add texture and depth.

The purple shadows are picked up in the background wash to unite the painting, and I have interlocked the shapes and directional hang of the flowers to create the illusion of movement.

The pencil drawing and reference photographs.

You will need

HB pencil

Compasses

Plastic eraser

300gsm (140lb) NOT paper, approximately 33 x 25cm (13 x 10in)

Drawing board

Masking tape

Masking fluid and old paintbrush

Paintbrushes (Nos. 3, 7, 8 and 20)

Flat acrylic brush

Paper towel

Two water pots

Palette for mixing

Cobalt blue	Helio green	Winsor violet	Opera
May green	Perylene maroon	Aureolin	Scarlet lake

1. Use the compasses to draw a circle 25cm (10in) in diameter and sketch in the flowers. Apply masking fluid around the edges of the main flowers (leaving out the small leaves) and outside the circle. Use an old paintbrush, and remember to keep just inside the pencil outline of the flowers.

2. Make a dark green mix of helio green and maroon. Dampen the lower part of the background using a large, No. 20 brush.

Tip

You can dampen and paint the background in sections – you don't have to wet it all in one go.

3. Change to a No. 8 brush and start painting the background. Begin by dropping in the cobalt blue.

4. Next drop in the yellow, then the violet and finally the dark green mix.

Tip

Always choose background colours to complement the flowers you are painting.

5. Tip the board to spread and merge the colours. Pick up any droplets with the tip of a damp brush. Try not to touch the paper with the brush when you do this, otherwise it will leave a mark.

6. Dampen the remaining parts of the background and drop in the colours in the same sequence. Allow the paint to dry thoroughly.

> **Tip**
>
> Avoid putting a different background colour each side of a stem, as in the top part of this painting – the colour needs to follow through.

7. Rub off all the masking fluid apart from that on the outer circle, and soften the edges of the painted areas using a flat acrylic brush. At the same time, straighten any lines that went adrift when you dropped in the background colours.

8. Start to paint the red parts of the flowers. Because the areas you are painting are small and fairly detailed, apply the paint to dry paper using a No. 3 brush. Lay on scarlet lake, followed by Winsor violet for depth if needed, allowing the colours to mix on the paper.

9. Leave the highlights white. Drop in May green at the tops of the flowers.

> **Tip**
>
> If you are frequently swapping between different colours, keep the colours on different brushes.

10. Continue building up the reds. For more depth of colour, start with a light wash of red, then drop in a darker tone of the same colour.

Tip

If you are using a dark and a light tone of the same colour, mix up the darker tone then take a brushful to a separate palette and add more water for the lighter tone.

11. Put in the leaf on the right-hand side of the painting. Lay the paint on to dry paper, starting with May green and then dark green. Allow the colours to mix on the paper.

12. For the shadows, make a fairly watery purple mix of Winsor violet and cobalt blue. For softer edges, glaze the shaded areas first with clear water, then drop in the paint.

13. For the stamens use a light wash of opera, then while the paint is still wet, drop in the purple shadow at the top.

14. Allow the painting to dry and remove as many pencil lines as you can using a plastic eraser.

15. Assess the background, and lift out any foliage that has been painted over. Gently stroke the area you wish to lift off with a damp, flat acrylic brush, then blot with absorbent paper.

16. Bring out the leaves in the background by painting in the negative spaces. Dampen the area first (if it's large) and then lay on the dark green mix using a No. 7 brush.

17. Bleed out colour where necessary by laying clear water on to the background and pushing it up into the colour you wish to bleed out.

18. Lift out the leaves in the bottom left-hand part of the painting, then glaze over them using aureolin.

19. Glaze the bud using scarlet lake.

20. Paint the veins on the flowers using the point of a No. 3 brush. Avoid using a smaller brush, otherwise you may need to reload it before completing a vein – it is best to paint veins in a single stroke, gradually lifting the tip for an increasingly finer line.

Tip

Veins can look too harsh when they are first painted on. Soften them when dry by glazing with water or a light tinted wash.

21. Put in the areas of red at the tops of the white petals.

22. Assess the picture, and bring out the flowers where necessary by painting in some negative shapes. Use the dark green mix and a No. 7 brush.

23. Add veins to some of the leaves (not all of them) by putting in the negative spaces between the veins. Use a watery mix of the dark green.

Tip

You may prefer to mask out or pencil in the veins before putting in the negative spaces behind them.

24. Bleed the paint out to the edges of the leaves.

JANET WHITTLE

25. Leave your painting to dry, then remove the masking fluid from the outer ring and any remaining pencil lines. Stand back and assess your painting, and make any final adjustments you feel are needed. I have deepened the reds and the shadows, put a few purple leaves in the background, added a little more pink to the stamens and glazed the paler leaves once again with aureolin.

Petunias

40 x 28cm (16 x 11in)

Petunias are wonderful plants for growing in containers such as baskets and pots, and are therefore ideal for practising drawing from life, as I have done here. To focus the viewer's eye on the flowers I have faded out the edges of the basket to purples and blues, tipping the basket slightly to give fewer horizontal lines, then broken these up with leaves and moss.

A pencil drawing of the petunias shown above.

A pencil drawing of the convolvulus shown below.

Convolvulus

30 x 23cm (12 x 9in)

This highly invasive plant in the garden nonetheless looks lovely as it winds its way over the hedgerows. The flowers have a very short life span, depending on the weather, but are soon replaced by others. To give the painting perspective, observe how far the centre of each flower is from its edges in each direction; this will 'tip' the flower either one way or the other.

Anemones

The vibrant colours of these flowers make them an all-time favourite of mine. Like poppies, the centres of the flowers are the main focal points, and putting them in immediately draws the painting together.

I have allowed the background colours to push the flowers forwards, as the leaves are further down the stems and rather delicate. By dropping in areas in the same colours as the flowers, you have the option of cutting out more flowers from the background wash later, as I have done here at the top of the painting.

The pencil drawing.

JANET WHITTLE

The reference photographs.

You will need

HB pencil

Plastic eraser

300gsm (140lb) NOT paper, approximately 33 x 25cm (13 x 10in)

Drawing board

Masking tape

Masking fluid and old paintbrush

Paintbrushes (Nos. 3, 6, 8 and 20)

Flat acrylic brush

Paper towel

Two water pots

Palette for mixing

Opera Winsor purple May green Paris blue Cobalt blue

Helio turquoise Scarlet lake Indanthrene blue Quinacridone gold Permanent rose

1. Draw the outline sketch and mask off the edges of the paper using masking tape. Apply masking fluid just inside the outer lines of the drawing and allow it to dry thoroughly. Prepare washes of opera, May green and Winsor purple, and a deep blue mix of helio turquoise and Paris blue and dampen the background using a large, No. 20, brush.

2. Drop in the paint using a No. 8 brush. Begin with pink, then purple.

3. Next drop in the green ...

4. ... and then the deep blue mix. Tip the board so that the colours blend on the paper.

5. Change to a No. 6 brush and add texture by dropping in a few small areas of purple using a pale mix. Tip the board to merge the colours, and soak up any drips using the tip of a damp paintbrush.

6. When the painting is completely dry, rub off the masking fluid with your fingers and brush it away with a large make-up brush. Soften the edges of the painting using a flat acrylic brush.

7. Dampen the leaves at the bottom of the painting and lay on a simple wash of quinacridone gold and May green.

8. To improve the composition, paint in the negative shapes behind another flower in the top part of the picture. Wet the paper first and then drop in the dark blue mix.

9. Put in the negative shapes between the flowers on the left-hand side of the picture using the same mix.

10. Paint the centres of the background flowers using indanthrene blue, laying the paint on to damp paper.

11. Paint the shadows separating the petals within the background flowers using a mix of opera and a little Winsor purple. Apply the paint to dry paper and soften out.

12. Emphasise the left-hand background flower by dropping in the opera and Winsor purple mix around its base. Bleed the paint out into the background with clear water.

13. Put in the negative shapes around the leaves at the bottom of the picture using a blue-green mix applied to a dry background.

14. Strengthen the background at the bottom of the picture, and cut out the stem to the right of the leaves by painting in the negative shapes. Dampen the area first and then drop in indanthrene blue and May green. Add more opera, May green and helio turquoise to the top right-hand side of the background. Allow the paint to dry.

15. Glaze the petals of the main left-hand flower, and lay on quinacridone gold, then a little May green. Work on one petal at a time, glazing and laying colour on to one petal before moving on to the next.

16. For the centre of the flower use a strong mix of Winsor purple.

Tip

Work alternate petals so that they have time to dry before you paint the ones in between.

17. Put in red highlights on the petals using the wet-on-dry technique. Use a No. 6 brush.

<div>

Tip

Don't worry if you paint over the stamens – these can be painted later with a darker mix.

</div>

18. Going back to a No. 8 brush, lay a clear water glaze over one of the petals of the red flower, then drop in pink followed by red. Leave some space between the red and the pink to allow the colours to merge naturally and create a more gentle change in tone. Leave the highlights white.

<div>

Tip

Pink enhances red and gives it a 'glow'; red on its own can look flat.

</div>

19. Now paint the main blue flower using the same method as above. Drop in pink first, and then a mix of cobalt blue and Winsor purple. Leave the pink showing in the lighter areas.

20. Use fine brush strokes for the folds in the petals.

101

21. Paint the remaining flowers. Use opera with a touch of cobalt blue on the two pink flowers, and a mix of cobalt blue and Winsor violet on the two remaining blue flowers. Use the same techniques as for the flowers you have already painted.

Tip

Vary the tone to add interest and create depth to your painting.

22. For the stamens in the centres of the flowers, use indanthrene blue painted on with the tip of a No. 3 brush. Use delicate strokes on dry paper and leave some flecks of white to brighten them.

23. For the mound in the centre of each flower, use a watery mix of the same colour. Soften in the white where necessary to avoid too much of a 'speckled' look.

24. Complete any remaining parts of the flowers, and lift out the stalks with a flat, damp brush.

25. Lift out some of the colour from the main blue flower on the left to lighten it.

26. Lift out the background colour to create the yellow flower's stalk.

27. Strengthen parts of the background on the left to accentuate the left-hand flowers. Use the No. 8 brush.

28. Assess the finished painting and make any necessary final adjustments. Here I have defined the leaves by deepening the negative shapes, added more colour to the flowers, glazed back the centres of the flowers using a mix of permanent rose and cobalt blue, and laid a soft glaze of helio turquoise on one or two of the petals.

Anemone Circle

23cm (9in) diameter

Anemones are a welcome sight in spring, with their deep and vibrant colours. I have used the flower colours in the background to add interest, but kept it simple by using wet-in-wet and avoiding adding too many leaves. I have introduced counterchange by placing the darkest flower colours next to the lightest ones.

Anemone Bouquet

28 x 30cm (11 x 12in)

Glass is interesting to paint, with its strong highlights and reflected colours. By keeping the background colours mainly in the top two-thirds of this painting, the jar has been painted dark against light, with the suggestion of a reflection on its surface.

Daffodils

I so look forward to the first daffodils pushing their way up through the soil after winter. The particular ones I have painted here are white, so I have introduced gold and green into the background as shafts of light to reflect the qualities of the more common golden varieties. I have echoed the sunlit effect created by the initial wash throughout the painting. By putting the negative shapes behind the leaves, they look as if light were shining on them, and I have placed cast shadows underneath the flower heads for counterchange.

The leaves have a lot of blue in them and I have exaggerated this for effect, going from dark against light to light against dark on the left-hand side.

The pencil drawing.

The reference photographs.

You will need

HB pencil

Plastic eraser

300gsm (140lb) NOT paper, approximately 33 x 25cm (13 x 10in)

Drawing board

Masking tape

Masking fluid and old paintbrush

Paintbrushes (Nos. 6, 7, 8 and 20)

Flat acrylic brush

Paper towel

Two water pots

Palette for mixing

Helio turquoise

Translucent orange

Helio green

Winsor purple

Cobalt blue

Perylene maroon

Quinacridone gold

Scarlet lake

May green

1. Begin by drawing the outline sketch and masking off the edges of the paper using masking tape. Apply masking fluid just within the outer lines of the drawing and allow it to dry thoroughly. Make up a dark green mix of helio turquoise and helio green. This will be used to paint the negative spaces between the leaves.

2. Apply a water glaze to the background using a large, No. 20, brush, taking the water up to the masking line.

3. Change to a No. 8 brush and drop in quinacridone gold, then May green. Imitate sunlight coming through from the top left corner by laying the paint diagonally.

4. Finally, add the helio turquoise. Tip the board from side to side to spread the paint, and pick up any drips that gather in the corners with the tip of a damp brush. Allow the painting to dry.

Tip

Always allow your background to dry flat, otherwise the paint will carry on moving.

Tip

If there are any gaps where the glaze didn't quite reach the pencil outline, they can be filled in while the paint is still wet by pulling the paint up to the outline with the point of a brush.

The completed background. Note how much the paint diffuses.

5. Before removing the masking fluid, paint in the negative spaces between the leaves at the bottom of the painting when it is dry. Don't make them too dark at this stage. Using a No. 7 brush, dampen the area first and then drop in the dark green mix followed by May green. (May green is transparent, so the background yellow will show through.) Allow the two colours to mix on the paper.

6. To give a soft edge to a negative space, dampen the paper beyond the area you wish to paint and then drop in the colour, allowing it to merge gently into the background.

7. To achieve areas of light, dampen the yellow and bleed out to the colour in the areas surrounding it.

Tip

As you put in the negative spaces, follow each stem and leaf down to its base to ensure the foliage looks realistic. Go over and behind other stems for a three-dimensional effect.

8. Continue to cut out the leaves by putting in the negative shapes between them. Paint behind more leaves if you need to.

Tip

To fill large areas, remember to dampen the paper first. For smaller spaces, work on a dry background, keeping a wet edge.

9. Work your way across the painting, darkening the background between the leaves where necessary.

11. Give depth to the foliage by darkening the background leaves at the points where they cross behind another leaf, and soften out the edge. Allow the painting to dry.

10. Put in the negative shapes at the top of the painting.

Tip

Soften hard edges by running a damp brush along them.

12. Remove the masking fluid and soften the edges of the background using a flat acrylic brush. Rub out the pencil lines from the leaves using a plastic eraser. Using a No. 6 brush, add a yellow glow to the petals around the centre of each flower. Wet the area you wish to paint first, then drop quinacridone gold into the centre and allow it to spread outwards, leaving a soft edge. Tip the board if necessary, but make sure the pigment does not reach the dry area.

13. Allow the centres to dry, then apply a wash of scarlet lake mixed with a little translucent orange. Vary the tone by applying a lighter tone first followed by a darker tone and allowing the two to mix on the paper. Paint the inner part of each flower, avoiding the area where the stamens lie, or else mask these out.

14. Using wet-in-wet, add a touch of perylene maroon to the edges of the centres to add more tone.

15. Put the shadows on the petals using a mix of cobalt blue and a touch of perylene maroon. Dampen the paper first, then drop in a small amount of colour and allow it to spread. It is all right for the paint to bleed into the yellow in some places. Refer to the photographs to position the shadows accurately. Allow the painting to dry and rub out as many of the remaining pencil lines as you can.

16. Deepen the tone in the centres of the flowers, and put in the detail. Use scarlet lake to deepen the orange in the folds, and the dark green mix for the shadows around the stamens. Apply the paint to a dry background using wet-on-dry.

17. Define the stamens using quinacridone gold.

18. Put a glaze of yellow behind the two main petals of the bud.

19. Accentuate the flowers by placing a shadow beneath them. Use a light wash of helio turquoise applied with a large brush on to dry paper. Soften the edges of the shadows by painting into them with a damp brush.

20. Complete the painting by softening edges where necessary, lifting out highlights and going darker into the negative spaces next to the petals to increase tonal range, deepening some of the shadows with cobalt blue and Winsor purple, and warming some of the leaves with a glaze of quinacridone gold.

Oriental Poppies
71 x 51cm (28 x 20in)

Occasionally I use colours from the same part of the colour wheel to accentuate the flowers, as in this painting. I have used pinks and purples to depict a different plant in the background, cutting it out from the first washes.

Spring Bouquet
30 x 38cm (12 x 15in)

This painting is a celebration of spring. After the winter months, colour in the garden is always such a welcome sight. The cool white of the daffodils counterchanged against the warmer colours of the tulips creates an attractive balance.

Irises

These flowers bloom and die quickly, but they are so elegant and regal, and the colours so rich and vibrant, that in full bloom they are absolutely breathtaking.

Irises are complicated flowers to draw, and you will need to make some sketches in order to fully understand their complexities, but it is well worth the effort.

There are endless possibilities for combining colours as well as shapes and sizes of irises, and it can be difficult to make a decision with so much choice! To achieve the deep purple of the foreground flower requires two sometimes three glazes, so you will need to use a paper from which paint does not lift easily. The golden iris in the background acts as a foil to the three white flowers, interconnecting the composition.

The pencil drawing and reference photographs.

You will need

HB pencil

Plastic eraser

300gsm (140lb) NOT paper, approximately 33 x 25cm (13 x 10in)

Drawing board

Masking tape

Masking fluid and old paintbrush

Paintbrushes (Nos. 3, 6 and 20)

Small flat acrylic brush

Paper towel

Two water pots

Palette for mixing

Quinacridone gold Opera Aureolin Helio turquoise

Winsor purple May green Helio green Cobalt blue

Indanthrene blue Scarlet lake Perylene maroon Hooker's green

1. Draw the outline sketch and mask off the edges of the paper using masking tape. Apply masking fluid just within the outer lines of the drawing and allow it to dry thoroughly.

Tip

With an irregularly shaped outline, it may be difficult to take your water right up to it. Check for any dry areas by holding the picture up to the light and tilting it.

2. Make a mix of indanthrene blue and Winsor purple. Dampen the background using a large, No. 20 brush.

3. Begin to paint the background by dropping in areas of quinacridone gold around the white flowers. Use a No. 6 brush.

4. Next drop in May green, followed by Winsor purple. Tip the board to mix the paints and pick up any droplets using the tip of a damp brush.

5. Drop in the mix of indanthrene blue and Winsor purple for the darker areas. Tip the board again to merge the colours.

6. Strengthen the background where necessary while it is still evenly damp, and allow it to dry flat.

7. Put in the small areas of background between the flowers using May green.

8. Now put in the negative spaces between the leaves and stems using a dark green mix of helio turquoise and helio green. Drop in the dark blue mix for the darker areas below the petals.

9. Strengthen the small negative shapes using the dark green mix.

10. When the painting is dry, put in slightly darker negative shapes within the ones you have already cut to make more leaves. Allow the paint to dry, then rub off the masking fluid and soften the edges of the background. Because the outline is irregular, use a very small flat acrylic brush.

11. For the lower petal of the yellow flower, mix quinacridone gold with a little opera to warm the tone. Wet the paper then drop in the yellow, allowing the paint to spread and form a soft edge. Drop in small areas of maroon for the darker areas and the veins.

12. For the lighter petals use aureolin, then drop in a little quinacridone gold for the darker tones.

13. Paint in the 'beard' using scarlet lake applied using small, sharp strokes with the tip of the brush.

121

14. Paint in the shadows on the white petals using cobalt blue mixed with a little Winsor purple. Use the photographs to position the shadows accurately. Work one petal at a time, first wetting the petal then dropping in the shadow mix. Complete alternate petals, then the ones in between.

Tip

Don't attempt to put in all the shadows you can see in the photograph, otherwise your picture will become too complicated.

15. Continue painting the shadows on all the white petals. Add the 'beards' using opera and quinacridone gold mixed together and applied with the tip of the brush using short, sharp strokes.

16. Use May green and quinacridone gold for the papery leaves at the base of each flower.

17. For the pink areas on the white and purple flower, drop in a little opera and blend it into the shadows using a damp brush.

18. For the dark petals, wet the paper then drop in opera followed by Winsor purple. Make sure the purple goes on over the pink, otherwise it dries very dull.

19. Allow the purple to spread into the pink. (You could do this in two separate washes.)

20. Leave small areas of white at the base of each purple petal.

21. For the buds, first wet the paper then drop in May green, followed by Winsor purple and finally indanthrene blue.

22. Complete the buds and their stems, using May green and quinacridone gold for the papery petal at the base of each bud and the stems.

123

23. Paint in the green veins on the white petals using May green. Use the tip of a No. 6 brush and complete each vein with a single brush stroke, so make sure the brush is well loaded with paint.

24. Darken the sides at the base of the flower, and then glaze over the green veins when dry using quinacridone gold to soften them.

25. For the fine veins covering the bulbous part at the base of the white flower, use May green applied with a rigger – a long-bristled, No. 3 brush.

26. Apply the veins to the equivalent part at the base of the white and purple flower using the same technique, but this time with quinacridone gold. Strengthen the darks beneath some of the flowers using the dark blue mix, and complete any remaining red markings.

27. Use maroon to accentuate the veins on the dark yellow petal, and then strengthen the colour by glazing over the petal with the maroon wash.

28. Apply the same wash to the centre of the yellow flower and drop in the dark blue mix at the base of the main petal to create shadow and therefore depth. Strengthen the shadows on the white flowers to give the petals more form and paint on the veins using a rigger. Use the shadow mix described in step 14.

29. Allow the painting to dry and remove all the remaining pencil lines. Assess the painting and add any finishing touches you feel may be needed. For example, I softened some of the hard edges, reinforced the shadows, laid a glaze of indanthrene blue over the purple petals, strengthened the greens using helio turquoise and Hooker's green, deepened some of the negative spaces, added some veining to the leaves and glazed the yellow iris with aureolin.

Jelly Roll and Honky Tonk Blues

71 x 58cm (28 x 23in)

The names of these irises amused me, and I felt the peaches and blues complemented each other well.

The petals of the blue iris have turquoise, pinks and purple in the initial wash to give the final glaze a glow. I have kept the leaves soft in the top right-hand corner, with no added details, dropping in a suggestion of a blue iris in the background along with some quinacridone gold to warm the cooler greens.

Irises in the Rain

46 x 25cm (18 x 10in)

Raindrops can add atmosphere to a painting, but take a little practice. For best effect, use them sparingly.

Index

anemones 94–105, 128

background
 washes 10, 12, 20, 25, 31, 41, 42, 44, 46, 50, 56, 58, 63, 70, 75, 84, 94
 colours 24, 43, 46, 49, 60, 63, 73, 74, 77, 86, 87, 94, 104
bleeding out 50, 52, 60, 90, 91, 92, 99, 110
bluebells 47
buds 17, 25, 27, 42, 74, 79, 82, 90, 113, 123
butterflies 22, 30, 47

cockling 8, 42
colours
 complementary 28, 30
 mixing 14–15, 16–17, 18, 20, 22, 44, 53, 56
 opaque 15, 16, 18, 22
 palette 6, 8, 29, 42
 semi-transparent 15
 transparent 15, 17, 18, 20, 45, 55, 109
composition 6, 14, 22, 26, 28, 30, 32, 33, 34, 38, 42, 44, 45, 46, 52, 54, 70, 84, 98, 116,128
convolvulus 30, 93
counterchange 29, 37, 50, 70, 81, 104, 106, 115
cutting out 22, 25, 49, 70, 74, 94, 100, 110, 115, 120

daffodils 106–115
depth 6, 17, 18, 20, 42, 44, 45, 53, 54, 56, 70, 84, 102, 111, 125
drawing 6, 9, 13, 34–41, 43, 52, 54, 60, 70, 84, 92, 93, 94, 97, 106, 108, 116, 118

focal flowers 25, 30, 49, 55, 60, 66, 67
folds (in petals) 53, 77, 101, 112
foliage 30, 42, 84, 89, 110, 111
forget-me-nots 31, 60
fuchsias 84–91

glazing 6, 9, 15, 16, 17, 18, 20, 41, 45, 46, 47, 48, 55, 58, 66, 67, 76, 77, 78, 79, 88, 90, 91, 100, 101, 103, 108, 109, 113, 116, 124, 125, 126

hard edges 49, 60, 67, 76, 111, 125
highlights 20, 24, 37, 87, 100, 101, 104, 113
hollyhocks 40
hydrangeas 25, 59

irises 20–21, 28, 45, 116–127

lifting out 46, 89, 90, 102, 103, 113
light 14, 15, 17, 24, 32, 47, 50, 52, 58, 59, 70, 106, 110

masking out 25, 42, 44, 46, 50, 52, 56, 58, 60, 62, 73, 86, 91, 97, 108, 111, 118

negative shapes 22, 25, 26, 28, 31, 40, 45, 49, 50, 52, 54, 65, 67, 74, 79, 80, 89, 91, 98, 99, 100, 102, 106, 108, 109, 110, 111, 113, 120, 125
negative spaces see negative shapes

paper
 choosing 8, 42
 stretching 13, 42, 43
peonies 25, 58
petunias 92

photographs 6, 14, 23, 24, 27, 32, 42, 56, 58, 60, 65, 72, 84, 96, 106, 112, 116, 122
poppies 23, 27, 31, 41, 50, 54, 94, 115

rhododendrons 16, 49
roses 32, 33, 70-83

scabious 15
sea holly 23
shade 14, 24, 88
shadows 16, 18, 20, 24, 32, 52, 53, 56, 58, 59, 67, 70, 77, 78, 79, 82, 84, 88, 91, 99, 106, 112, 113, 122, 125
sketches 6, 26, 30, 40, 42, 54, 62, 73, 97, 108, 116, 118
soft edges 10, 46, 49, 60, 64, 67, 75, 76, 87, 88, 98, 110, 111, 113, 120, 121, 125
stalks 32, 36, 46, 47, 50, 54, 80, 81, 84, 87, 94, 100, 102, 103, 110, 120, 123
stamens 17, 50, 65, 70, 72, 79, 88, 91, 101, 102, 111, 112
stems see stalks
still life 6, 32
strelitzia 14
sunflowers 18, 29
sunlight 29, 46, 47, 58, 59, 108
sunshine 56

texture 32, 33, 37, 56, 84, 98
tonal range 18, 113
tonal value 34, 40, 44, 50, 58
transferring the design 10, 42, 43
tulips 24, 60–69, 70, 115

veining 10, 48, 50, 52, 67, 90–91, 124, 125
vignetting 6, 27, 54

watercolour pencils 12, 41
wet-in-wet 12, 14–15, 20, 29, 41, 45, 46, 48, 49, 56, 60, 64, 65, 77, 80, 81, 104, 112
wet-on-dry 49, 52, 74, 100, 112

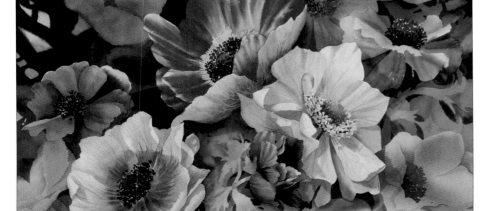

Anemones

On finishing this painting I felt that 'cropping' it to a smaller size would help the composition. It is a technique that will often improve a painting you are not entirely happy with when in the final stages.

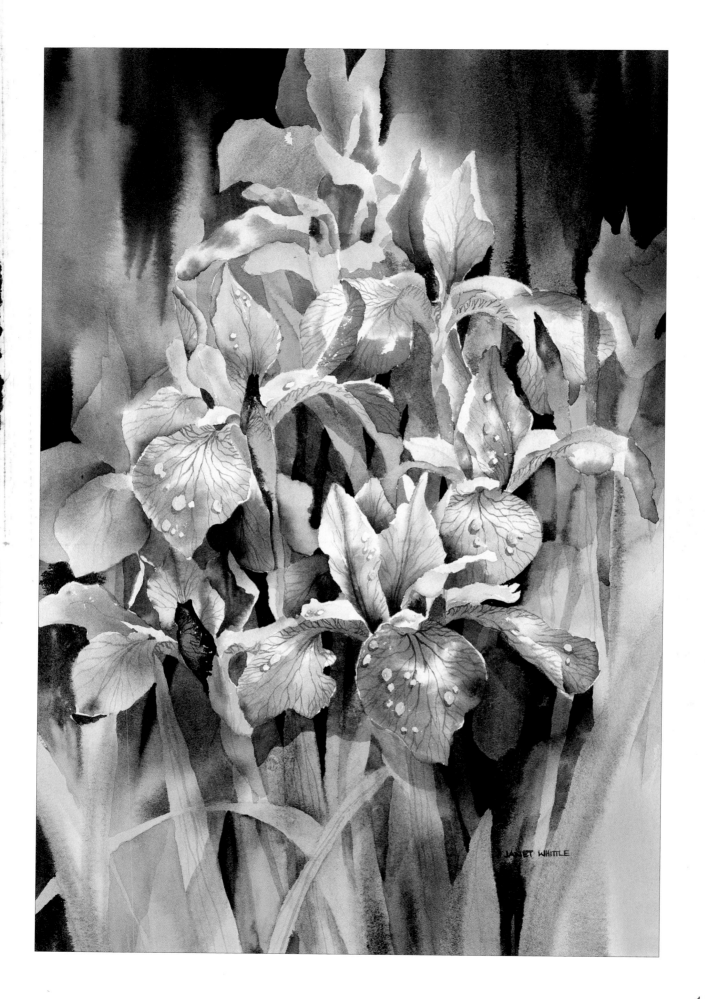